Photolanguage

Also by Robert U. Akeret

Tales from a Traveling Couch

Family Tales, Family Wisdom

Photoanalysis

Not by Words Alone

Photolanguage

How Photos Reveal the Fascinating Stories of

Our Lives and Relationships

Robert U. Akeret

W. W. Norton & Company

New York · London

Quote on page 19 copyright © 1968 Paul Simon
Used by permission of the Publisher: Paul Simon Music

For more information about permission to reproduce selections from this book, write to
Permissions, W. W. Norton & Company, Inc., 500 fifth Avenue, New York, NY 10110

The text and display of this book are composed in Centaur.
Composition and book design by Chris Welch
Manufacturing by The Courier Companies, Inc.

Library of Congress Cataloging-in-Publication Data
Akeret, Robert U., 1928–
 Photolanguage : how photos reveal the fascinating stories of our lives and relationships /
Robert U. Akeret.
 p. cm.
 ISBN 0-393-04968-X
 I. Personality assessment. 2. Photographs—Psychological aspects.

BF698.4 .A54 2000
770'.I'9—dc2I 00-038033

W. W. Norton & Company, Inc., 500 Fifth Avenue, New York, N. Y. 10110
www.wwnorton.com

W. W. Norton & Company Ltd., 10 Coptic Street, London WCIA IPU

I 2 3 4 5 6 7 8 9 0

*To the photographers
who made this book possible*

Contents

Why assume that to look is to see?
—Pablo Picasso

Introduction

My premise is a simple one: *There is more going on in most photographs than we usually see—and that "more" is endlessly fascinating.*

By looking at photos with a critical eye and a fluid imagination, we see stories emerging: stories about the complexities of relationships; stories about personal quirks and desires; stories about how life changes and how it remains the same; stories about how time and place shape our lives.

In a sense, photographs are a language unto themselves. And so, to understand this language in all its nuanced vocabulary and subtle syntax, we need to approach photographs with the openness of a child who is learning to read and the intensity of a cryptologist who is trying to break a code.

But above all, we must approach photographs with our imaginations. We need to enter into them and feel our way around them, much the way a good psychotherapist approaches a patient's dream—

from the inside out. Like much of psychology, photoanalysis is more art than science, more akin to literary analysis than it is to data analysis. It is a form of *critical free-association stimulated by images.* We search the photographs for bits and pieces of the stories they tell, then assemble and shape these stories in our imaginations.

How, then, can we know if the stories we have come up with are "true"?

We can't. Just as when we analyze a poem or novel for meaning, we can never be certain if we have come up with the "definitive" analysis. But as in literary analysis, the more we know about the material in question, the closer our interpretive analysis can come to some sort of literary or poetic truth.

Our primary interpretive tool is one that has been known to artists and writers for millennia: reading human gestures and facial expressions for their emotional content. When Julius Fast wrote his seminal book, *Body Language,* he brought this artist's skill into the realm of general psychological knowledge. We learned to look more closely at people's bodies for clues to their feelings about themselves and about the people around them. *Are those clenched hands a sign of anxiety? Anger? Does that faint smile signify affection for the person next to her? Does that stiff upper lip belie extreme self-control? Stoicism? Fear?*

Photolanguage is a remarkable subset of body language. Because the gesture and expression is frozen in the still photograph, we can study it much more closely than a gesture or expression that passes quickly before our eyes. Not only does it "hold still" for us so we can look closely, but it remains undiluted by the gestures and expressions that precede and follow it. Further, we can look at it over and over again for a layered study that digs incrementally beneath the surface to the emotional truth. And what is more, we can literally look more closely at body and facial language in a photograph by holding it close to the eye or looking at it through a magnifier (or even producing a blow-up for detailed study).

Our other basic tool is the information and background stories we bring to bear on the photograph. Yes, it is great fun to try to inter-

pret a photo "blindly"—that is, without any prior knowledge of who the people pictured are or what was actually going on when the camera snapped. (Indeed, we will play this game of "blind analysis" from time to time throughout this book.) But just as a good literary critic arms herself with all available background information when she analyzes a novel—the cultural history of the period in which it was written, biographical material about the writer, etc.—a good photoanalyst arms herself with everything she can that seems relevant to the recorded image. *Who are these people? What brought them together at this particular moment? What was this place like at that particular time?*

No, this isn't cheating; it is simply bringing the story *around the photograph* to bear on the story *depicted in the photograph.*

One often neglected story around a photograph is the subject's and photographer's *intent. What does the subject want the viewer to think about him by what he projects in this photo? And what is the photographer trying to make us believe by the way he has framed and posed the photo?*

These questions become particularly relevant when we analyze publicity shots of celebrities and news photographs of publications that have a particular political or social ax to grind (that's just about all publications I know of). But these are only the most obvious examples, because even the most casual family snapshot is filtered through some self-consciousness on the part of both subject and photographer.

Just to make our task even more difficult and fraught with ambiguity, there is what I call the "Rorschach effect," after the Rorschach Test, in which subjects interpret the "meanings" of ink blots. This refers to the third "story" that we need to take into account when we analyze a photograph for psychological and social content—the story that we, the viewers, *project onto the photograph.*

We do not approach any photograph blankly, as a *tabula rasa;* rather, we come to it with our own assumptions, prejudices, preoccupations, fears, etc. And inevitably, we project some of these onto the photograph and into the stories we "find" in the photograph. In short, the stories we find in a photograph may sometimes tell more

about who we are than about the people pictured in the photograph.

But like the Rorschach Test, this can provide us with a wonderful tool to help us understand ourselves. In fact, what originally brought me to photoanalysis was the use of photographs in psychotherapy to ferret out hidden and unjustified assumptions and fears. For unlike the Rorschach Test, there was some objective (or, at least, *alternative*) truth evident in the photographs to test the patient's assumptions against. *You said this photo showed how little your father felt for you, but what I see on his face is extreme personal pain, the self-absorbed look of a drinker. Did your father drink?*

What we have, then, are three stories for every photograph—the story we find *depicted* in the photograph, the story *around* (or behind) the photograph, and the story we *project* onto the photograph. Perhaps it is where these three stories intersect that we find the "true" story we have been searching for.

What began for me as a powerful tool in psychotherapy gradually and quite naturally expanded to include virtually every photograph I looked at. Looking through my own photo album, I would find myself wondering what hidden stories were being revealed here that I had never noticed before. Seeing a photograph in a newspaper, I would find myself asking what was *really* going on here as compared to what the caption and story under the photograph *claimed* was going on here. Soon, I was spending more time analyzing these photographs for story content than reading the accompanying texts themselves—and sometimes with more interesting and edifying results.

In the following pages, I have assembled a great number of photographs in which I have found fascinating stories—stories that may not be readily apparent at first glance. I have grouped these photographs and their stories in sections that represent my special interests as a psychologist and as a person drawn to the literary aspects of life. In fact, you could justifiably say that the choices and sequencing in this book represent my own personal "Rorschach effect."

But that's not the half of it. My interpretations are idiosyncratic;

they represent my assumptions and prejudices as well as my analytic expertise. But there is method in my idiosyncrasy. I have no intention of teaching photolanguage with theories of analysis or with hard and fast rules for interpretation. Like any language, this one is best learned by immersion, by "hearing it spoken." And so I want to take you on a journey of my personal interpretations of photolanguage, to teach by example, to show you how I do it.

Do not always expect to agree with my interpretations. In fact, if you do, I will not have taught you well.

Chapter 1

A Dedication to Immortality

I have a photograph / Preserve your memories / They're all that's left you.
— Paul Simon, "Old Friends"

A friend of mine was traveling in Greece visiting ancient ruins. He strolled the paths of the original Athena where Socrates had tread, wandered through the first Olympic Village, sat on a cool stone bench in the amphitheater where Euripides's plays were performed over two thousand years ago. My friend then took a ferry to the verdant island of Corfu, specifically to see the burial site of a Greek philosopher from the fourth century B.C. And there, in a noisy bus station in Corfu Town, he found himself sitting next to a seventy-year-old Greek gentleman who had just picked up some prints at a photo shop and was going through them with obvious delight.

In a matter of minutes, the old Greek was showing the photographs to my friend, telling the story that went with each one: who was who; what they were doing; what was going on in his life on that particular day. The photographs were fairly ordinary—family members on the patio, family members in the garden, family members helping him fix his car. About the only extraordinary element in the

photos was the odd snake or lizard that appeared in some along with the family members—the old Greek's hobby was collecting and taming wild reptiles. My friend was still politely looking at these photographs when his bus pulled into the station. He stood and said goodbye.

"Would you like to keep one of the pictures?" the old Greek suddenly asked.

"Sure," my friend replied. He pointed at one of the man with two of his nephews. The Greek wrote his name on the back—Hectoras Bouletsis—and handed it to my friend.

"Never forget me," the old Greek blurted as my friend walked away.

Never forget me!

"Those words really struck me," my friend told me recently. "And they have stayed with me ever since—along with that photograph which I framed and put on my study wall at home. That photograph is this man's plea for immortality—his relic for the ages. And the fact is that as long as that picture hangs on my wall, he *will* have a token of immortality that is as real as any ruin or tomb or statue that I saw on my trip. I truly never will forget him."

........................

"Never Forget Me." This souvenir of a chance encounter in a Corfu bus station shows more about the once-anonymous Hectoras Bouletsis than we might at first see: it speaks of the affection and respect the old Greek's nephews feel for him. Clearly both young men are reluctant to get close to the snake draped across their uncle's shoulders—the nephew in the hat is jutting his body as far from it as he possibly can. Nonetheless, the boys place their heads close to old Hectoras's, an act of love and fealty.

With the invention of still photography in the mid-nineteenth century, every man and woman in the Western World could suddenly preserve his image. (In pre-camera days, only artists and the rich possessed concrete images of themselves, their family, and their friends,

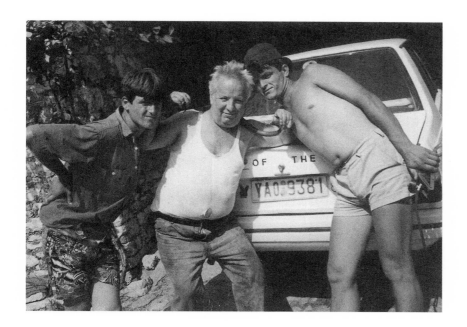

in the form of drawings, paintings, and sculpture.) And indeed, along with this remarkable invention came a unique and democratic form of immortality—an immortality that not only preserves our lives, but perhaps more importantly, preserves the *stages* of our lives.

The story of a Kosovar refugee tells us how much we have come to depend on photographs to give our personal histories meaning and legitimacy. This refugee had to flee his home in a matter of minutes and was only able to carry a few essentials on his escape. When he reached the safety of a Macedonian refugee camp, he was overcome with grief because he realized that he had left behind a cherished photograph of himself as a schoolboy wrestling champion. Yes, he said, I have a vivid memory of that youthful triumph, but without the photograph it is not completely *real* for me. The thought of the occupying Serbian soldiers burning that photograph was unbearable for this man. *To him, it was as if they could eradicate his past.*

Look at this photograph of Italian rescue workers uncovering family photographs on the site of a mammoth flood disaster—a tidal wave let loose by the crumbling dam of the Vaiont Reservoir in the Italian Alps destroyed everything in its path, including over two thousand people. This picture reveals yet another perspective on the significance of photographs as relics of personal histories—we see their impact on the *viewers* of the photographs. In a sense, it is like a hall of mirrors, because we are *viewers of the viewers* of the photographs and their reaction reflects and triggers our own response.

........................

The grim and solemn faces of the rescue workers unearthing these family pictures shows that they sense the meaningfulness of their find. Surely, these are men who have quite recently dug up corpses on their tragic mission, yet the emotional power of uncovering these snapshots clearly strikes them very hard too. *This is all that is left of this family's life. This is the last trace of their having lived at all.* We can easily imagine one or more of these workers making it his business to preserve these photographs. They are testaments to the lost lives. *They are traces of immortality.*

As I study the faces of the men regarding these photographs, their sense of wonder and sorrow is echoed in my own heart.

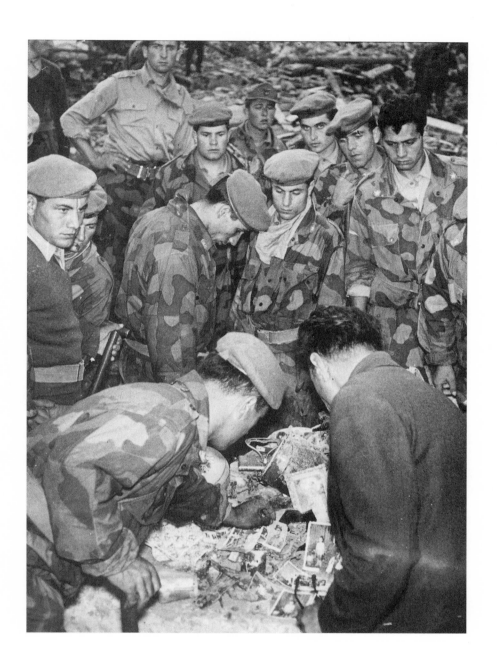

Time and Time Again

Most of us remember the first time we saw time-lapse photography in a movie theatre or on a television screen. It was usually a speeded-up sequence of a natural phenomenon—say, a single rose budding, flowering, fading, and dying all in the course of seconds. The sequence evoked a bittersweet sense of wonder—the marvel of the cycle of life, the melancholy of its evanescence.

The photographs we keep of the stages of our own lives evoke similar feelings. We marvel at the changes we undergo as we—and those close to us—grow up and age. We also marvel at the qualities in ourselves and others that *remain the same* over intervals of time. We are struck by the turning points in our lives that are documented by these photographs, the way they capture the essence of the "chapters" in our life stories. And just as we felt a certain melancholy at seeing the entire life of the blooming rose transpire before our eyes, we feel a soulful, almost heroic melancholy as we see our lives flash by with the turning of the pages in a photo album.

Time-lapse photographs speak to us in a wonderfully literary language when we study them for emotional meanings, meanings supplemented by the stories that go with them. Both the marvel and the melancholy are deepened for us.

One rarely changes in a mirror. You may look at yourself once a day every day for eighty years and not once say with certainty, "Ah, I look older than yesterday (or wiser, or more mature)." Most of the changes in our life come by infinitesimal degrees: millimeters of physical growth, milligrams of personality alteration. And yet, by studying our photographs, we can detect and isolate many of the significant turning points of our lives.

One way we can try to locate these turning points is by comparing photographs of ourselves at different times in our life and looking for changes that occurred in the intervals between them. The most obvious changes, of course, are physical. Seeing yourself robust-looking one year, drawn and thin the next, you can isolate a period of ill health, depression, or, perhaps, deprivation in your life. And, to be sure, you will see changes in style—the clothes you wore and how you wore them. In itself, this can be a clue to other changes in your life, like your financial and professional status.

But studied carefully, a chronological series of photographs can reveal subtler transformations: changes in attitude and character, even changes in values. Read acutely, time-lapsed differences in body language and expression point to changes in such traits as confidence, shame, hopefulness, and despair. And certainly a series of group photographs offers clues to changes in interpersonal relationships—changes, say, in affection and estrangement or trust and wariness between people.

Seeing that a significant change has occurred during an interval of time, we inevitably ask ourselves, "What happened between this picture and that one that accounts for this change?" Often, with the aid of photographs, this question shakes loose nearly forgotten episodes in our lives, changes of circumstance and relationships, or perhaps personal realizations and resolutions that marked the beginning of a new trajectory in our lives.

"Plus Ça Change"

"Plus ça change, plus c'est la meme chose."
[The more things change, the more they remain the same]
—French proverb

Here is a pair of time-lapse photographs that tell a marvelous and happy story: the first is of a woman named Julie Michaels holding her newly adopted daughter, Lily, in the midst of three administrators of the orphanage in Woo Han, China, where Lily had spent her first year of life; the second photo was taken six years later in Massachusetts—Julie and Lily with a group of close friends at an Easter party.

.....................

For all the differences in these two photographs—differences of time, place, and culture—I am most struck by the similarities in them. In particular, I marvel at that wondrous, life-affirming smile on Julie's face; it is virtually the same in both photos. In fact, in the second photo that smile seems to have multiplied—it is almost perfectly replicated on her daughter's face, as strong an argument for the influence of nurture (as compared to nature) as I can imagine.

Let's look again at that first photograph. Everybody (except the baby) is smiling and the quality of those smiles appears to be both genuine and loving. Those expressions on the faces of the orphanage personnel, the easy manner in which the two women touch each other, and the literal "openness" of the man's posture all suggest that Lily was in very good and loving hands (and arms) during her first year of life. (The several weeks Julie Michaels spent visiting the orphanage confirmed this impression.) And Julie's expression at this moment as she is becoming a mother for the first time speaks not only of her utter happiness, but of her complete confidence. She appears neither awkward nor nervous—she looks totally ready for her new role and adventure. There is not a scintilla of doubt on her face—she knows she is doing the right thing, she is fully commit-

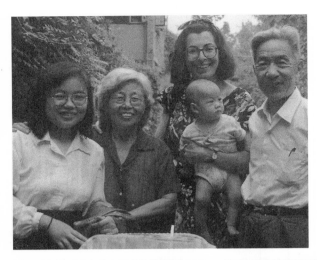

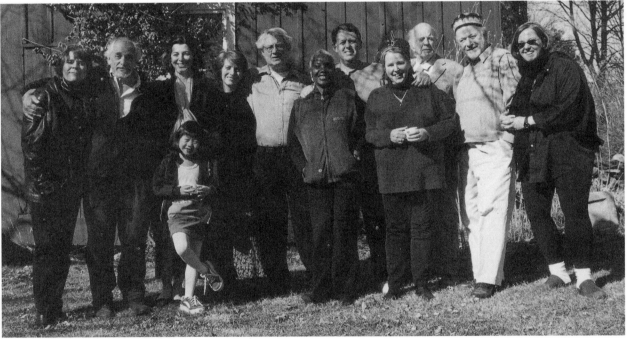

ted to it, and she is positive that her life with Lily will be a good one.

The second photograph confirms every expectation expressed in the first. Lily, now seven, has acquired not only her mother's smile, but apparently her confidence as well. There is something fresh and witty about her grin and her humorously suspended crossed leg—a comic casualness, a little sight gag for her father, who took the photograph. Both grin and gag bespeak a child who is self-assured. And the way she has positioned herself squarely in front of her mother, bracing her jokey pose against her mother's belly, shows exactly where her sense of security comes from.

Finally, it is interesting to compare the people surrounding mother and daughter in each photograph; the first is Lily's extended family in China, the second her extended family in America. Neither group is blood relatives, but both groups surely appear to be warm, loving families—it is right there in their faces, in their interlocking arms and hands. (Lily calls most of the men and women in this second photo "Uncle" and "Aunt.")

Manipulating the Gestalt

There is a particular genre of time-lapse photographs that I am especially fond of—a sequence of pictures of the *same* people in the *same* place (and often *same* pose) at *different* times. Many families instinctively shoot photo series like these, often connected to repeating occasions, say everyone standing around the Christmas tree year after year after year. By keeping place and subjects constant, the differences wrought by the passage of time are accentuated. We can focus on them more easily.

Gee, Sandy didn't even come up to Mom's waist that Christmas, but here he is towering over her just seven years later.

My God, that's where Grandpa always stood—just behind Ricky.

Here is a trio of young girls on a wagon in front of a barn, all at the age of three, and then again the same trio on the same wagon in the same spot (but different season) twelve years later, at the age of fifteen. It is interesting to note that the photographer placed the three on the wagon in the same order, but did *not* instruct them to assume the same poses.

......................

We are immediately struck by the somewhat comic relativity of scale: in the first photo, the girls fit easily on the wagon; in the second, it is obviously a balancing act for them all to fit at the same time. *My, how the three have grown,* we think. But as we continue to gaze at the photographs, looking closely at the facial expressions and body language of the individual girls, we are struck by how very much each of them has remained the same as they grew into young women.

The dark-haired girl on the right appears shy and ill at ease at both ages three and fifteen. Her smile appears to require a determined effort at both ages; her folded hands suggest a need for self-control; and her position with respect to the other two girls—apart and self-contained—again shows the shyness and aloneness that appear to be enduring qualities of her personality.

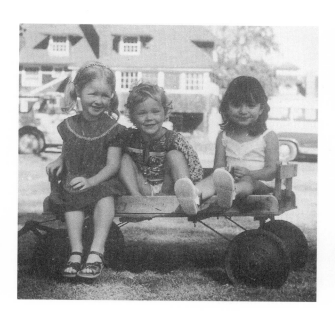
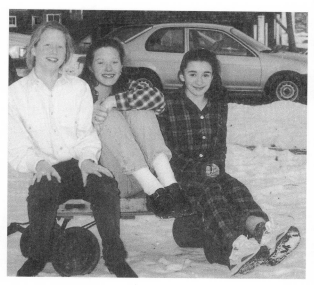

The contrast with the girl in the middle is striking. Even as a three-year-old, this one seems very comfortable smiling for the camera; her confidence, especially in her appearance, had already been established at that young age and has stayed with her as she grew into a young beauty. Also, the way she leans into (and slightly behind) the girl on her right shows her natural connectedness to others, another quality that has not changed over time. (In fact, she had had little contact with either of the other girls over the intervening years.)

What strikes me most about the girl on the left are her hands—very much "out there" in both photographs. Unlike the girl on the right who holds her own hands tightly, this girl's hands are separate, her fingers apart and extended—all of which suggest *action*. Already at three, she is grasping the world, reaching out to manipulate it.

Today, these three are in their early twenties: the girl on the right is studying philosophy at a major university; the girl in the middle is on her way to becoming an actress and singer; and the girl on the left is preparing to be a midwife—about as "hands-on" a profession as there is. *Plus ça change*, indeed!

When a time-lapse sequence of photographs is stretched to encompass a major chunk of a lifetime, the result is often overwhelming. Here's one that spans fifty years in the life of a mother and son. In the first photograph, they are walking down a boulevard in Zurich where they lived when the boy was just starting life; in the second, the two are walking down the same boulevard when the mother was near the end of her life.

....................

"The blink of an eye." Those were the mother's first words when she saw these two photographs side by side. At that moment, the speed at which life goes by was magnified—like the rose that bloomed and died in accelerated motion pictures. But looking at these two photographs a few hours later, the mother had quite a different reaction. *"Oh, all the stories that go in between these two pictures. They could fill a library!"*

In the early photo, she is striding confidently into life with her one and only child, pulling this diffident-looking boy along, seemingly urging him to propel himself forward as positively as she is. (Her marriage to the boy's father was failing by then; she already knew that she and her son would have to survive on their own.) In the later photo, she is a great-grandmother several times over. Now she has to lean against her son to make her way, but the confidence she hoped to transmit to her son so long ago seems definitely to have taken hold—now *he* is striding confidently forward, urging her to follow along.

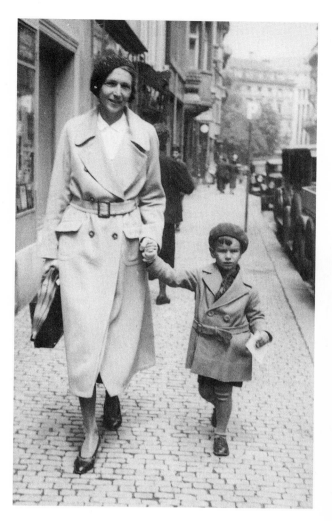

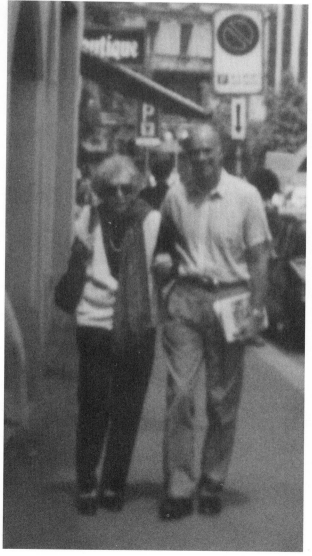

Symbol or Cause?

Just for fun, compare these two studio portraits of a young European woman that were taken only a couple of years apart. Obviously, the young woman is much more spirited and unabashed in the second photo than in the first—*small* lapse of time, *big* change in personality. But are there any clues to the cause of this transformation in the photographs themselves?

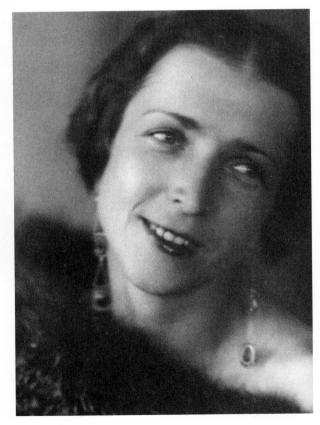

"Those earrings made all the difference in my life," this woman told me many years later. "You can see it on my face!"

Brought up in a strict, middle-European, Victorian-era family, she had not been permitted to have earrings as a teenager. Her parents were convinced that they would "send the wrong message" to young men—a wanton, sexual message. But despite her background—or more likely in reaction to it—the young woman had her ears pierced. *"I persuaded our cook to do the piercing with a needle and cork. It hurt terribly, but was well worth it to me."* Her parents were furious and still forbade her to wear earrings. It was not until she left home to attend acting school that she finally got to wear them—and to have this defiant act documented in a glamorous and somewhat seductive photograph.

To this day, the woman believes that it was the earrings which transformed her. And when I suggested that the earrings were merely the *symbol* of her own willed transformation, that they were her public declaration of her liberation from her family background, she laughed. *"No, it was the earrings that changed me!"* she still insists. Could it be that we are both right?

One last thought: Photographs are not only valuable tools for psychological interpretation, but for sociological and socio-historic interpretation as well. In the first photograph, the woman is still very much a product of Victorian society and we see this in more than just the absence of earrings. We see it in her tightly pursed lips (parted lips were thought to send a sexual message too), and we see it in the elaborate buns covering her ears. In that period, ears were considered provocative organs—a mysterious, labyrinthine opening to the body reminiscent of other scandalous body openings. (The Victorians, one waggish historian has noted, possessed truly filthy minds.)

Finding Patterns or Creating Them?

Obviously, when we shoot a series of related pictures and when we gather a series of related pictures together in an album, we are imposing our own ideas of what qualifies as related and what does not onto the sequence. In this way, the photographer, the album-assembler, and the viewer project something of themselves onto the subject of the photographs. And then the question arises: are we learning more about the personality of the subject of these photos or about the expectations, desires, and fears of the people who took and assembled them?

Take, for example, these two sequences of photographs of two young boys. Each sequence was shot and assembled by their respective parents.

.....................

This series, shot over the course of three years, appears to demonstrate that young Will is a precocious and rather singled-minded musician. The first photo sets this theme up: Give him a rake at a year and a half and he'll hold it—and strum it—like a guitar! A year later, he is found in the living room playing the mandolin. And a half-year after that, there he is again, strumming and singing like a troubadour. The fact that Will's father is a professional guitarist makes the boy's interest in music seem perfectly natural. *Will comes by it honestly,* we think.

But is what we are seeing pose or content? Is Will aping his father's actual music-making or just his father's oft-seen gestures? Is he genuinely interested in music or just trying to be like Dad? And, ultimately, is there a clear difference between these two phenomena? Aping his father's gestures with musical instruments could very well be the first step leading the boy to a genuine interest in music.

But then comes the question of whether these photographs are representative or not. The photos were taken and assembled in this sequence by his parents, who encourage their son's interest in music. Could they, for example, just as easily (and just as accurately) have

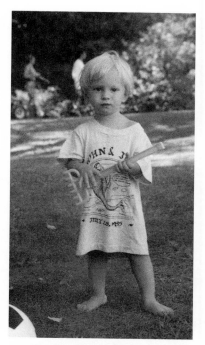

taken and assembled photographs of young Will playing with dirt? Photo One: Will makes mud pies; Photo Two: Will makes a little dam at the seashore; Photo Three: Will makes muddy footprints on the kitchen floor. Perhaps. And then we might project ahead that Will is destined to be a civil engineer or some such. But those are not the photographs his parents took or chose to assemble. Is it relevant that such a sequence does not figure in their aspirations for their son?

The above question takes on special interest from a psychoanalytic point of view. Will grows up not only with his parents' aspirations, but with *photographic documentation of who they perceive him to be.* The photos comprise what I call a "photo album superego." Looking at this sequence himself, Will must surely be convinced that he is devoted to music——*even if some part of him is not.* Later on, if he ever questions this interest or finds himself more drawn to some other interest, this photo sequence could come to confuse him. *If this is who I really am, would I be going against my nature to abandon music?*

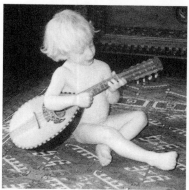

The second series, also taken over the course of three years, seems to document this youngster's fascination with weaponry and war. Again, remember that this sequence was shot and assembled by his parents. And add to this the fact that both his parents are pacifists. Does this sequence tell us more about the boy (Nicky) or about his parents' trepidations about him?

The one-and-a-half-year-old Nicky as ersatz Robin Hood with a bow and arrow hardly looks brutal or even angry. Actually, he looks more cherubic than war-like. And surely one of his parents fashioned that paper hat for him, hardly an act of discouragement in his enterprise. In the next photo, Nicky at two-plus is happily displaying his Christmas gift—a sword that appears to be the product of some television show or film. Once again, we tend to ask: *Who bought him this gift?* Yes, it may very well have been the gift he asked for—even *begged* for—but someone, presumably an adult, granted him his wish. The third photograph, taken aboard the aircraft carrier *Intrepid* when Nicky was three, shows him having the time of his life as he pretends to be manning the massive anti-aircraft gun. And again we may think, *Who took him there and why?*

In light of the questions raised in the sequence of young Will and his musical instruments, we may very well wonder if the sequence of young Nicky belies something in the personalities of the people who took and posed the photographs and who presented them in this sequence. Are they documenting their fears about their son rather than something significant in his nature?

Alas, I have withheld some critical anecdotal information here. When Nicky was still using a baby bottle (long before he ever had any toy weapons), he would frequently take the bottle out of his mouth, turn it around, point it at other people, and go, *"Pow! Pow!"* And his mother tells this story of when Nicky was still a toddler: she was watching a symphony orchestra on television and Nicky wanted to know what the conductor was holding in his hand. *"A baton,"* she told him. As he looked around at the rest of the orchestra, Nicky asked, *"And what are those other weapons?"* And today, as a teenager, he spends much of his time playing computer war games.

Looking again at this sequence of photographs, we may think that they *are* an accurate document after all. Accurate, yes, but keep in mind that such photos may represent only one aspect of a personality. A different selection might portray Nicky as the friendly, caring boy that he is.

Photo Sequences as Statements: Interpreting Our Personal History

When we shoot and arrange photographs in a particular sequence, we are not necessarily projecting unconscious wishes or fears on the images; instead, we may very well be making a conscious personal statement about our lives and the lives of the people around us. The sequence represents our interpretation of our personal history, just as a memoir or autobiography represents a particular interpretation of a personal history. (Inevitably, the memoirist chooses which incidents in her life to recount and which not, let alone her point of view on these incidents.)

We see a good example of photo sequence as a personal statement in the two photographs on the facing page. The sequence also serves as an example of the way we can manipulate the gestalt in a sequence of photographs to emphasize a particular personal-historical theme: by keeping the location constant while both time and personnel change.

These two photographs taken on the Stein am Rhein Bridge are separated by sixty years of personal history. The first is the rather elegant wedding procession of a young couple; the second is a photo of the product of this marriage, the older man in the middle (with his children and grandchildren).

..................

Like most wedding photos, this one looks propitious—a hopeful future lies ahead. But alas, this is the wedding of the same woman pictured earlier with her son on a street in Zurich—divorce will end this marriage in only four years. (Rare indeed is the wedding photograph that in some way—an expression of guilt or apprehension—anticipates a bad marriage. And in any event, such photographs never find their way into wedding albums.)

The second photo broadcasts hope too—a coherent family clearly enjoying themselves. In this case, the hope is well founded—the two succeeding generations of marriages in this family are, in fact, very happy ones.

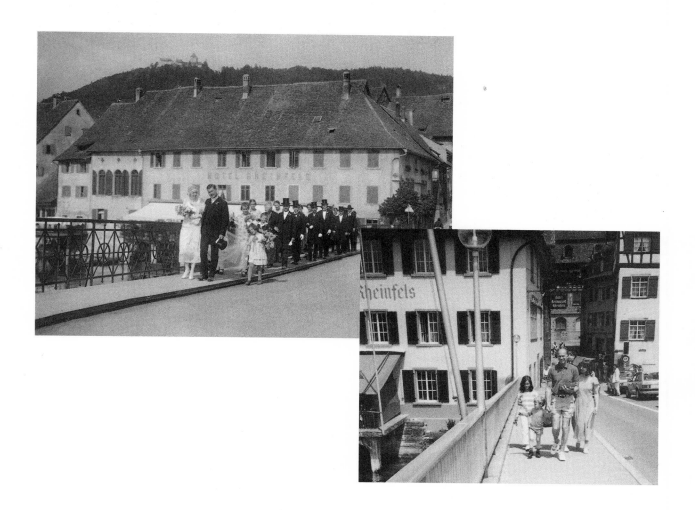

What is most telling about this pair of photographs is found not so much in the pictures themselves *but in the decision to pair them* in the family album. This decision was made by the "man in the middle"—the son of the failed marriage, the father and grandfather in the successful marriages. Pairing the two is his statement of triumph: *Out of this union that looked so hopeful but failed, happiness and harmony have finally prevailed!*

Keeping the venerable bridge as a constant in both photographs accentuates this theme beautifully. It is as if the new family is taking up where the hopeful wedding party left off, not only "bridging" generations but also bridging a failure with a success. And the endurance of the old bridge (and the Rheinfels Hotel in the background) from one personal era to the next is a sturdy symbol: *Where there is endurance, there is always hope.*

"In Dreams Begin Responsibilities"
—Delmore Schwartz

Allow me to close this chapter with a still photograph from one of my favorite movies, Federico Fellini's *8½.* This film is the ultimate photo sequence as personal memoir, albeit a *staged* memoir.

...................

Near the end of the film *8½,* Marcello Mastrianni, Fellini's personal stand-in, reviews the people in his life as a ringmaster in a circus. In this fantasy sequence, time parades by him. It captures his naughtiness (attempting to pinch one of the women), his "arrested development" (the boyish grin on his handsome face), and his will-to-power bordering on cruelty (the whip in his hand.) It is hardly a flattering self-portrait; indeed, the film is loaded with guilt and self-incrimination. But the unbridled joy conveyed by this sequence overpowers all other feelings. It seems to say, *Yes, for all my failings, life has been a delight for me and the people around me.*

Amen to that.

Chapter 3

The Purity of
Frozen Passion

Photography's greatest contribution to our understanding of what it is to be human derives from its ability to freeze an image—to stop time. A human expression frozen in time allows us to study and review it, to take as long as it requires for us to enter into it, empathize with it, and attempt to comprehend it.

And the expressions that most fascinate us are of the *pure and honestly felt extremes of emotion.* We seem to hunger for the intensity of these powerful feelings. Many of us feel that we are somehow too inhibited or fragmented by the complexities of life to experience them. Another reason we may feel deprived of these pure and extreme emotions is because of the generalized hyperbole of popular culture: Peaks of emotion are dramatized as routine events in television series, advertisements, and films. Characters go from utter despair to raucous laughter to beatific serenity from one commercial break to the next. People exhibit ecstatic reactions to driving a new car or biting into a slice of pizza pie. And so we find our *real* emotional lives com-

peting—badly—with The Actors Studio. Perplexed, we ask ourselves how we can ever know when we truly feel pure and extreme emotions in such an all-pervasive environment of artificially expressed emotions?

Candid still photographs offer us a way to connect with genuine powerful emotions. By studying these photographs and empathizing with the people in them who are experiencing and expressing these emotions, we can reclaim them for ourselves. We have before us documentary proof that these emotions do, in fact, exist in genuine, unrehearsed experience. Purity of passion is verified and in the process becomes a possibility for our own emotional lives. As a result, our lives can become immeasurably richer.

Public Displays of Pure Emotion

Public displays of pure emotion are a good place to begin separating artificial and staged emotions from the genuine article. Examine this photograph of Michael Jordan.

The setting is a public situation, an NBA game in front of thousands in the stadium and millions watching television. Add to this the fact that this superstar is known to be extremely conscious of himself; in interviews, he frequently refers to himself in the third person, saying things like, "Michael Jordan always knows how much time is left on the clock." Yet, is there any trace of self-consciousness in his face here?

......................

The intensity and urgency of Jordan's yell are written large all over his expressive, muscular face. Notice how he's using his right hand as a megaphone. We especially see that intensity in his eyes; they look almost feral, a wild will to dominance, as if this were not just a game, but a battle for survival. The straining cords of his neck are also evidence of how totally committed he is to the moment. *"Don't hold anything back!"* his expression says. *"Take no prisoners! Do absolutely whatever it takes to win!"*

It is, of course, this ferocious commitment to winning that has made Jordan the singular athlete he is. No matter how great his natural talent surely is, it had to be harnessed to the will and intensity captured in this photograph for that talent to be fully realized.

Is this a "staged" portrait of an extreme emotion? It certainly does not look that way, no matter how long one studies this photograph. Yes, Jordan is undoubtedly conscious of the effect of his expression on the people looking at him—*but that is the point! He is urging others to feel and exhibit the same intensity that he has.* But this self-consciousness is not the same as artifice: Jordan's expression of emotion is real *and* public.

One of the reasons that young people all over the world have become such extraordinary athletes—far better than just a generation ago— is that they watch professional athletes on television. With replays and slow motion, the young boys and girls are able to study these professional athletes' moves, to copy their choreography. But a still photograph such as this one of Jordan also provides a model they can emulate: a model of raw intensity and commitment.

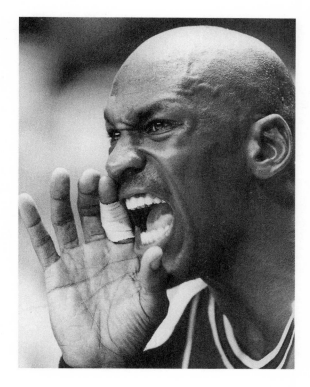

It is interesting to compare Jordan's emotional display with that of a superstar athlete of a previous generation, the "Yankee Clipper," Joe DiMaggio. Here is Joltin' Joe crossing the plate after hitting yet another home run in 1941.

....................

In analyzing this photograph we must remember, first, that games were not yet televised in this era—one either saw the athletes at some distance from the stands or in the sports section of the newspaper in photographs such as these. Undoubtedly today, knowing that his

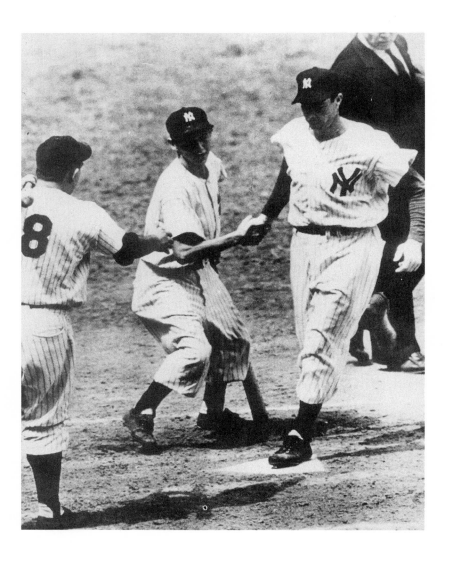

image is being captured and instantly broadcast in close-up has a big effect on a public personality, if only unconsciously. Second, we must remember that by its very nature, baseball is more of an individual performance sport than basketball. The batter is out there alone, solely responsible for his production.

But do these two caveats alone account for the contrast between Jordan's and DiMaggio's very different emotional displays? DiMaggio appears serious in the extreme and preternaturally calm, given the occasion. Yes, there is an intensity here too, but it all seems to be focused on touching home plate—*doing it right, playing by the rules*—even though there is nothing or no one to prevent DiMaggio from accomplishing this simple task.

But looking closely at DiMaggio's expression, we are also struck by something else, an emotion that seems almost antique by today's standards: Joltin' Joe looks *modest*. He is not playing to the crowd; on the contrary, he appears almost embarrassed by his feat. His down-cast eyes are not merely to keep an eye on the plate, but to say to the fans, *"I'm just doing my job, friends—that's all."*

The contrast between Jordan's raw, brazen enthusiasm and DiMaggio's serious and subdued modesty tells us something not only about these individuals, but about the radically different sports cultures of these two generations. DiMaggio was the epitome of the strong, silent type, a masculine ideal of the '40s and '50s. Parents encouraged their sons to be like Joe—serious, hardworking, and unassuming. That was the American way and it had its obvious rewards—fame, fortune, and, in Joe's case, Marilyn Monroe. Today's athletes thump their chests, raise their fists in triumphant salutes to themselves, and appear in advertisements that glorify not only their prowess but their arrogance. Modesty is passé. Today, modesty is considered "phony." In fact, modesty is viewed by some people as a sign of holding back, of not being fully involved or committed. This is the *new* American way, albeit one that gives some parents pause before they urge their children to "be like Mike."

When Private Goes Public (and Vice Versa)

For over a year, the American media were dominated by images of a rather ordinarily pretty young woman named Monica Lewinsky because she had been sexually intimate (in private) with the most public man in the world. The most frequently seen image was a fifteen-second clip of Ms. Lewinsky embracing the president at a televised meet-and-greet session that took place while their relationship was still private. She had been waiting for Clinton along with others who did not know him in order to perpetrate this public hug. For her, it must have been some kind of vindication and legitimization of their relationship—after all the sneaky, behind-closed-doors encounters in which she may very well have felt used, a public embrace was a declaration of their relationship. (It may also have been a personal challenge to him: *"Do you want me enough to risk this public exhibit?"*)

Not long after that incident, Lewinsky's relationship with the president (or at least the suspicion of it) became public knowledge and with that the young woman became a public figure in her own right. Stalked by photographers day and night, her every gesture, expression, pound of weight gain, and mode of dress were recorded by the media and then interpreted, analyzed, and criticized ad nauseum. Like other neophytes in the fishbowl of public life, she was tutored in how to mold and present her persona. And most of the photographic evidence points to the fact that she became rather adept at it.

But there were some public expressions of emotion that cut through all the control this young woman could muster. This is one of them.

Unlike the above-mentioned public embrace that Ms. Lewinsky planned and executed with her secret lover, this embrace is private *in spite of the fact* that it is being recorded by innumerable photographers and TV cameramen. This embrace was photographed as Ms. Lewinsky arrived in California to be with her father and stepmother for the first time after the scandal broke.

This could be the picture of any father comforting his daughter after a traumatic experience. If we did not know who these figures were and the caption read, *"A father and mother tenderly comfort their distraught daughter after she narrowly escaped death in a car accident,"* the entire image would make perfect sense to us.

But given what we *do* know, the image is even more emotionally charged. The pain and love on Mr. Lewinsky's face are heartbreaking. There is some tightness there too—we see it in the set of his jaw, the tightness of his lips—but it is a good guess that this represents the tears and helplessness he is holding back for his daughter's sake, not in order to present a dignified face to the world. He may also be feeling some anger with the photographers who are invading such a private moment.

At this moment, Monica Lewinsky looks nothing at all like the tawdry, calculating woman she was then being portrayed as; she looks like nothing so much as a little girl who got herself into a big mess and is only now finding a moment's peace and comfort in her father's

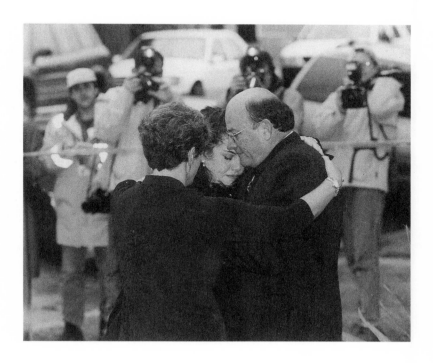

arms. We see something of a little girl's shame in her downcast eyes. She is trying to hold back her tears. It is photographs like this one that made many people feel that she was taken advantage of by her much older and more powerful lover. (Of course, as more of the story came out, we were confronted with a more complex picture of this young woman, and many of us were rather naively surprised to find that she was *both* an impressionable, fragile young girl *and* a seductive, ambitious young woman.)

The third member of this embracing trinity is Ms. Lewinsky's stepmother. She is at once outside the family drama and loyally protective of it, and her position in the tableau perfectly symbolizes that role: slightly apart, but dutifully there, arms encircling father and daughter.

Most significant for our purposes is how private this expression of pure and powerful emotion is despite the fact that it is taking place in public. And for us, the viewers, the image is all the more moving because we know the emotions expressed here transcend any self-consciousness induced by their publicness.

It is hard to resist pairing a photograph of Monica Lewinsky in the depths of genuine despair with a photograph of her lover at the height of hypocrisy. This, of course, is the infamous "I did not have sex with that woman" photograph (taken just days before the one of Ms. Lewinsky and her father), and it is a veritable clinic in how to lie convincingly.

Or is it?

Despite the fact that we now know what President Clinton said here was a bald-faced lie, it remains impressive just how much Clinton makes us *want* to believe him. Is it because he is such a good actor? Because he is so talented at *imitating* genuine, heartfelt emotions—in this case, the emotion of personal outrage? Or is it because in some sense he actually *feels* this seemingly fraudulent emotion and so we want to connect with his feeling even though we know that it is based on a distortion of the truth? (It is said that the best theatrical actors momentarily believe in the emotions of the character they are portraying, no matter how alien these feelings are to the actor as a person.)

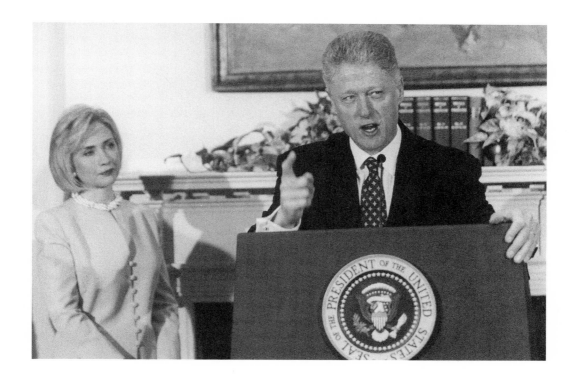

There are some clues in this photograph to the idea that Clinton actually believes what he is so forcefully saying. Note the impressive row of law books behind him. Like the presidential seal on his lectern, these books are a symbol of his authority, purposefully put there to give solemnity and weight to his pronouncement. But the law books may also serve as a personal symbol for the intricate legalism that Clinton is hiding behind in his own mind (a rather bizarre legal definition of what it means to "have sex").

Clinton is proud of his ability to "compartmentalize," and that, indeed, may be the secret to his convincing performance—the Bill Clinton pictured here apparently *owns* the feeling he is projecting. He *is* outraged. He actually *does* believe he is innocent. That is the secret to good acting.

But, at least with the advantage of hindsight, we can also find clues to Clinton's mendacity in this photograph. The Shakespeare line, "Methinks [he] doth protest too much," comes to mind when we focus on that wagging finger. He is not just shrugging this whole affair off as an awful rumor, he is *acting* the stern, moralistic teacher: *"Now listen here, you naughty children, don't believe everything you hear!"* In a sense, he is putting *us* on the defensive with this gesture. A clever tactic, but isn't it just a wee bit over the top?

Can't we see (at least in hindsight) that one part of the Great Compartmentalizer is worried about how this gesture and image will play if the truth finally does come out? Note the way he grips the lectern with his other hand. It certainly does not look relaxed; rather, it looks like he is grasping onto it for dear life. And then there is his mouth, a mouth that gives new meaning to the expression, "lying through his teeth." Many people have commented on the boyish smirk that always seems to be tugging at the corners of Clinton's lips when he is telling a whopper, and we certainly can see it here. It looks like the expression on one of the very boys this teacher might be scolding: *"Can't catch me, Teacher. I can get away with anything!"* Perhaps the little boy inside this big man not only got him in deep trouble, but is also fighting to make a public appearance himself.

Finally, we look at the first lady. Along with the presidential seal and the row of law books, she, too, is a prop in this carefully staged presentation, a prop that is supposed to say, *"Loyal wife not only stands by her man, but believes him."* She is coiffed, made-up, and dressed to be the very image of the good and proper wife. (For some reason, pearls always confer respectability on a woman.) Yet the canny stagemasters added a subtext to Hillary's appearance: she is made up to look almost Kewpie-doll pretty, and the peekaboo opening of her jacket, the down-the-front buttons, and the faint pucker of her breasts under the fabric announce that she is a every bit as sexually attractive as her supposed rival—more so, in fact. *So why*, we think, *would Bill dally with the less attractive Monica?* It was meant to convince us that, indeed, he did not do so. Now, however, knowing what did transpire, we are only left with the question, *Why, indeed?*

But despite all the stagecraft, we see something of Hillary's true emotions leaking out from behind the mask. Her eyes speak volumes. We see real pain in her right, partially closed eye. It appears long-suffering, almost tearful. While her left eye with its slightly arched brow looks more skeptical than loyal. It is the proverbial cold eye of appraisal. Along with the slight tilt of her head and the tight pursing of her mouth, this cocked brow seems to be saying almost ironically, *"Oh yes, I've heard this song before."* It is as if these two, very distinct eye expressions represent two competing feelings in her: hurt *and* disdain. They are real and powerful private emotions made all the more moving because there is such an effort to disguise them in public.

One question remains unanswered by this photograph: Is it her husband's alleged betrayal of the flesh that hurts Mrs. Clinton most deeply? Or is it her husband's betrayal of their joint political ambition? Perhaps each eye is giving a different answer.

The dizzying complexity of the relationship of public to private reached a new level in the Woody Allen–Mia Farrow–Soon Yi Previn scandal. Allen has made a career of portraying characters based on himself and played by himself in movies that poke fun at his nebbishy persona's romantic involvements. (What is more, he has often cast his current paramour as the character's paramour in these film comedies.) Most of the jokes in these autobiographical set-pieces play off the fact that the Woody Allen character is so self-involved and self-conscious, so neurotic and self-deprecating—in short, so painfully *private*—that connecting with a woman is tortuously difficult. But when Mr. Allen betrayed Mia Farrow, his real-life longtime companion, film costar, and the mother of his only child, with Ms. Farrow's adopted daughter Ms. Previn, the private lives of all three became a public drama that did not strike many as funny at all. (Was Allen, in a sense, having a sexual relationship with his own daughter? Having been Ms. Farrow's lover for eleven years, he had been on the home scene while Soon Yi was growing from little girl to young woman.)

Mr. Allen and Ms. Previn toughed it out, and although Allen lost custody of his only child, he gained the young woman whom he claimed was the love of his life, and he continued to make movies about pathetic, Woody Allen–type characters who just can't get it together enough to have a satisfying relationship. Throughout this very public ordeal, this man who has made a career of exposing his private problems vigorously protested the media's invasion of his privacy. It is the stance of a man who wants total control of how he is seen. But this candid photograph was out of his control.

If we did not recognize the pair in this photograph and were asked to guess what their relationship was, we might venture that it is an older man, possibly recuperating from an illness, going out for some fresh air with his nurse. The man is clearly much older than the woman; she appears to be a half-step ahead of him, leading the way; he has his arm through hers in a gesture that suggests she is bearing some of his weight; and she is dressed entirely in white (including

white shoes), like a nurse's uniform. The older-man-with-nurse inter-
pretation would make very good sense indeed.

But maybe this interpretation makes sense even if we know who
they are. Mr. Allen appears very Woody-Allenesque, which is to say,
awkward, relatively unattractive, and nebbishy: we see this persona in
the incongruous hat pulled comically low on his forehead, the nerdy
horn-rimmed glasses, the unruly hair on the back of his head, the

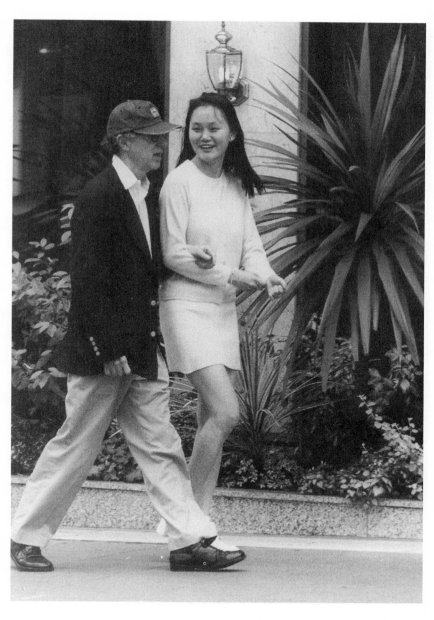

weakling slope of his shoulders, and the maladroit, almost effeminate way he clutches the hem of his jacket. Ms. Previn, on the other hand, looks youthfully strong (note her muscular legs), straight, confidently pretty, tenderly amused by something Allen is saying, *and very much in charge.* She *is* leading the way, she *is* bearing his weight, and she *is* cheering him up. Perhaps the love of Mr. Allen's life is not *officially* a nurse, but there may very well be something nurse-and-patient-like in their relationship.

This private dynamic may seem at odds with what we know and assume about Mr. Allen. That he chose a very young woman as his mate (indeed, a woman whom he may have helped form as she grew up) suggested that he wanted a woman he could shape and control. And this idea conformed to his reputation as a control freak. But the evidence here (corroborated in a subsequent documentary film about the two of them, *Wild Man Blues*), is that *she* is the dominant force in their relationship, *she* calls the shots, *she* provides the energy for the two of them by allowing Woody to latch on to her youthful vigor. *She* is the one who humors *him!*

As a psychoanalyst, I am not at all surprised. Time and again I have seen that this kind of passivity and dependency is the control-freak's secret dream. And that is because those with the greatest will to control are most often those with the greatest need for dependency; the willfulness is the way they protect themselves from the weakness of their neediness. So here we may be seeing Woody Allen finally surrendering to his genuine nature. And very happily so.

The Joy of Making the Private Public

One of the basic purposes of taking intimate photographs of ourselves with friends, lovers, and family is to freeze these moments in time. For example, we want a photograph of the bride and groom kissing so that we can preserve this moment and the feelings that go with it forever after. The photograph is our own, personal reminder to *"Never forget me (us) at this point in time."* The more "private" and hence intimate and heartfelt the image is, the better it serves this purpose. Looking at the photograph a year or ten or twenty later, we are brought back to these powerful feelings.

But such photographs serve the larger purpose of making private acts and feelings public—there for everyone to see, now and forever after. It endows these acts and feelings with a certain legitimacy. *This is real—You can see that right here!* In fact, one of the primary purposes of marriage itself is to make the private public. It is a public declaration of a private relationship. *"I am proud to announce my engagement to . . ."* *"I ask you to bear witness to this union."*

When actresses Ellen Degeneres and Anne Heche made their private love relationship public, they were acting on the same impulse as any other couple announcing their betrothal. Hiding the relationship had implied that they were somehow ashamed of it, and that is not at all how they felt. Making the private public was as much a statement to each other—*"I am proud to be your partner"*—as it was, say, a political statement. The expression "coming out" (meaning, "going public with one's gayness") has come to stand for the pride and the relief of making one's private feelings public.

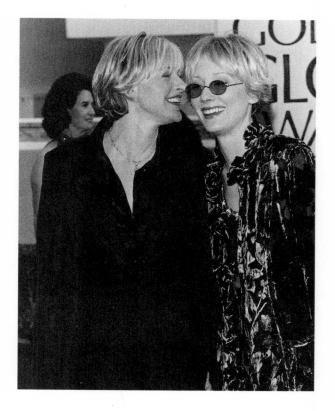

We are immediately struck by the spontaneous expressions of joy on both of these young women's faces—nothing actorish about those

smiles. Clearly, it is the joy born of being together, of touching each other (note their clasped hands near the bottom of the photograph), of sharing a secret whisper. In short, they give off the same happy "vibrations" as any young couple in the blush of new love.

One effect of this picture is to demystify the idea of a gay relationship: it looks like any other romantic relationship. For many of us, no matter how liberal we may aspire to be, the idea of a gay relationship and gay sex summons up images of tawdriness and degeneracy or, at the very least, *impersonal* sexual encounters. But here we are confronted with a very personal image, in fact, the very picture of romantic, caring love.

Here I may be projecting onto this photograph, but I cannot help but wonder if some of the exhilaration we see on the two women's faces comes from the thrill of going public with their once closely-held secret. (We know that they have come out at significant professional risk; film and television producers worry that an audience may not empathize with a known lesbian playing a romantic heterosexual role.) The giddy smile on Ms. Degeneres's face seems to say, *"We did it! We went public! Yippee!"*

And nothing is more public than an expression of a private feeling frozen for all time in a photograph.

The Dangers of Making the Private Public

When public figures complain (usually in the public media) about the horrors of losing their privacy, we are apt to think skeptical thoughts like, "Hey, being famous has made you a millionaire, so stop the bellyaching" and "If you want your privacy so badly, why do you keep posing for magazine covers?" In other words, we think that these people should accept the fact that they cannot have it both ways: be public figures *and* lead private lives.

But for royalty, being a public figure is virtually their entire job description. Being King or Queen, Prince or Princess is a ceremonial office in a quite literal sense: they must endlessly appear at public ceremonies—up to three and four a day. At these public events, they are living symbols of historical continuity, in this case the flesh and blood of, "There will always be an England." And so they are charged with projecting the dignity, serenity, confidence, and stability of the "eternal" royal family.

But alas, with so many of their waking hours spent in public, some of their private feelings are bound to leak out in unguarded moments. And if these unguarded moments are frozen in a photograph, they can speak volumes. (If we were to see a motion picture sequence of the scene below, the telling gestures captured in the still photograph might go by too quickly to register on us with any force; what is more, the gestures could become diluted in the context of "guarded" moments that project an entirely different—and *false*—emotional story.)

.......................

Taken at a VJ Day celebration when Prince Charles and Princess Diana were still ostensibly happily married, this photograph broadcasts a family rift in the making. Separated physically by their two sons, the prince and princess appear to be totally out of contact with each other: Di is having an intimate and seemingly happy moment with her younger boy, all her attention focused on him; and Charles is looking off in the opposite direction with a slightly pained, haughty, and almost testy expression of impatience on his face. It is

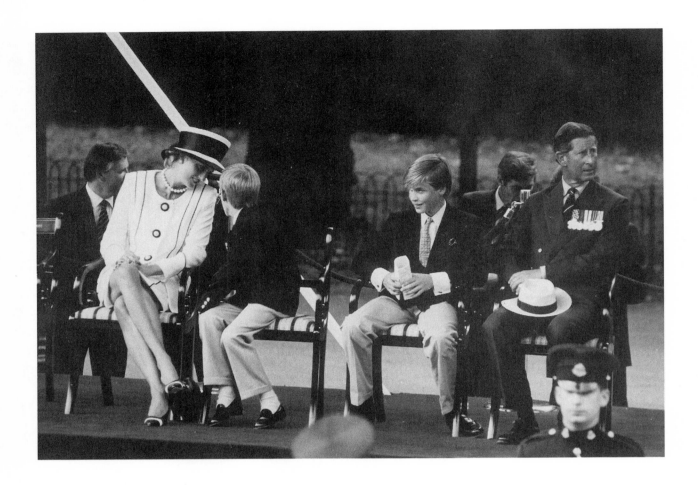

an expression that seems to say, *"What am I doing here?"* or, quite possibly, *"Let me out of here!"* In short, this appears to be the very picture of a dysfunctional couple.

(Prince Charles's expression reminds me of George Bush publicly—and *repeatedly*—looking at his watch during the Bush-Clinton presidential debates. That *"Isn't-this-over-yet?"* image, plastered on front pages of newspapers the next morning, labeled him in some voters' minds as a man who could not take the time to be bothered with ordinary people's concerns.)

This photograph is loaded with other clues to the dynamics of the royal family at this point in time, but my favorite is the evidence found in those four sets of legs and feet. Princess Di, as was her habit, was displaying her magnificent legs, front and center. Yes, she

is crossing them (although one effect of this is to reveal even more of her thighs), and her hands are discreetly positioned to hold her skirt in place, but there is definitely something jauntily sexy about the lady's legs. Is there a bit of defiance in this pose? A hint of *"Maybe you don't want me, but there are millions of men who find me attractive"*? Her husband, at the other end, holds both feet flat and firmly on the ground. Is this a sign of stability or merely of self-control? Or, given what we know of the prince's personality, could this be read as a sign of his earthbound humdrumness? Young Prince William, next to Charles, has his feet playfully looped around the chair legs, a position that matches the impish smile on his face, while his brother, Harry, has both feet *off* the ground, as if ready for action. (Could the tête-à-tête with his mother be about when he may go to the bathroom?)

What I personally find hopeful here is that in this unguarded moment, where the parents appear so painfully estranged from each other, the two sons appear at ease, secure, and, at least in the case of Harry, uncomplicatedly connected to his mother.

It is interesting to note the official caption given to this photograph by a British news agency: "The Princess of Wales chats to her younger son Prince Harry, as Prince Charles and Prince William watch the proceedings during the VJ service."

How's that again? Why, then, are Charles and William gazing off in totally different directions?

At this point, much of the press was still dedicated to perpetuating the myth of the happy royal family. The phony "spin" of their caption was their way of paying tribute to "There will always be an England."

The Ambiguity of a Public Face

As I pointed out in the photograph of Hillary Clinton "standing by her man," a facial expression frozen in time can convey conflicting emotions simultaneously. One fascinating subspecies of this phenomenon is when a public pose is disrupted by a powerful emotion causing both the self-controlled pose and the honest emotion to appear at the same time in a facial expression. The result is an interesting ambiguity, one expressive gesture battling with another and one expressive gesture belying the other.

This photograph of RJR Nabisco CEO Steven Goldstone and two aides was taken at a Congressional inquiry just after Goldstone had publicly admitted for the first time that cigarettes are dangerous to human health. (Not news to most of us, but a momentous admission for a man whose company stood to lose hundreds of billions of dollars in lawsuits if he *knowingly* endangered people's lives.)

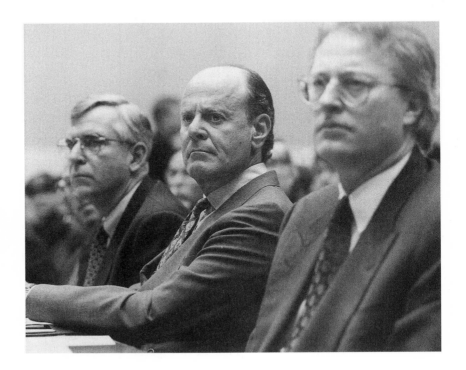

Goldstone's public pose is all power and brazenness. The tightly sealed, down-turned lips are a model of defiant self-control: upper lips don't come much stiffer than these. The forward gesture of his left arm also proclaims authority. In all, it is a pose that seems to say, *"That's it! That's all I'm saying, you bastards!"*

But the cat is out of the bag. He's said it all. The damage is done. And some part of this arrogant executive appears to be realizing that. We see it in his eyes, the "windows of his soul." Despite all the grim power in the rest of his facial expression, Goldstone's eyes belie his fear—even, perhaps, his pain. *He has just admitted to knowingly endangering people's health.* Again, I may be projecting far too much here, but could those pained eyes, struggling so vainly to remain steely, be revealing a dawning sense of guilt, as well as worry about the repercussions of what he has just admitted?

We have all experienced conflicting emotions and the confusion they engender in us. *Do I feel this way or that? How do I* really *feel?* And there is something oddly reassuring about seeing this all-too-human phenomenon captured in a photograph.

Public Pose, Private Insecurities

Even when public figures consciously create a pose for public consumption, we often find clues to their inner feelings in the picture. Not only can inner feelings leak out around the edges of the studied pose, but the choice of pose itself can tell us a great deal about how the poser feels about herself.

In this publicity shot of Judy Garland and Jackie Cooper, the two film stars appear to be having a grand old time clowning around. *We're just a fun couple here to entertain you*, is the implicit public relations message. But knowing that Ms. Garland suffered from painfully low self-esteem despite all her remarkable talent and appeal, we may suspect a distressing subtext to this comedic pose.

..................

The pose itself is obviously a gag about a big bosom—*See! I've got breasts as big as bowling balls! Ha!* At this time, when Ms. Garland was at the peak of her career, most of the major female stars were shapely, sultry, big-breasted young women, and none of these attributes applied to Judy Garland. Her appeal was that she was as fresh-looking and awkward as the girl next door—qualities that reflected her real personality.

Yet Garland's own romantic life was marked by sexual insecurities, and some of these insecurities undoubtedly contributed to her notorious drug and alcohol self-abuse. So what did it feel like to her to adopt a pose that, by implication, pokes fun of her own, modest-sized breasts? What prompted her to think up this pose—or, at least, to go along with it? Exactly what kind of a gag is it when the object of ridicule is one's own most vulnerable insecurity?

The answer might be that the chosen pose is itself a form of self-abuse. Examining Ms. Garland's brave smile—a smile that seems to exaggerate her overbite—and the girlishly vulnerable cast of her eyes—a look that seems to say, *"Like this? Does this make you laugh?"*—one thinks of Paliacci, the clown who was "laughing on the outside, but crying on the inside."

Poking fun at oneself is often considered a healthy way of dealing with insecurities. By externalizing our worst fears, putting them bravely out there, we show the world that we know them for what they are and are not afraid of them. Humor provides transcendence. But poking fun at one's most painful insecurities can also have the opposite effect. By going public with our pain, humorously or otherwise, we may end up humiliating ourselves—a subtle form of masochism. There is a fine line between the transcendence of poking fun at oneself and the masochism of the same, a line that can be fraught with ambiguity.

Of course, it could be argued that Ms. Garland's joke here is at the expense of the big-breasted stars. This bowling-ball exaggeration of their anatomy is a form of parody, *Breasts as big as bowling balls are ridiculously unnatural!* Indeed, that may very well be part of the intended joke, but again, knowing what we do about Ms. Garland's psyche, we can be pretty sure that it does not reflect everything that she felt about it.

Finally, let's look at Garland's accomplice in this gag, the comedic actor, Jackie Cooper. Judging by the way his left hand helps Garland prop up her bowling ball, we may suspect that he helped engineer the joke. By today's politically correct standards, that would make him culpable in a bad-taste female put-down, but the banal-verging-on-stupid grin on Cooper's face suggests that there is not much consciousness there, at least not enough to hold him responsible.

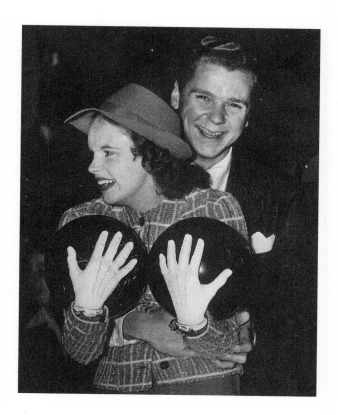

Public Figures, Private Moments

The photographs of public figures we tend to find most captivating are those of very human moments where the celebrity is too caught up in the ongoing situation to be self-conscious about how she appears or how she will be photographed. These photographs make the public figures real and accessible, standing as proof that they are "people like us."

In this candid shot of actress Elizabeth Taylor painstakingly being helped into the back of the car by her husband, actor Richard Burton, we see famous folk totally involved in their own private feelings, oblivious to the public (the photographer) watching them. The shot was taken at a point when Burton and Taylor were just reunited after a six-month separation, and Taylor was recovering from major surgery.

........................

There is little doubt that we are witnessing genuine concern as registered on Burton's face as he literally gives Taylor a helping hand. And Taylor's face appears to be stoically enduring her postoperative pain.

But do we detect something else on the famously beautiful actress's face? A hint of self-satisfaction, even vindication, in her lips that seems to be giving way at the corners to a kind of smirk?

Perhaps it is only our knowledge that *Burton* came back to *her* (bearing a giant, heart-shaped diamond pendant, no less) that induces us to read a look of triumph on Taylor's face. But in any event we are struck by the timing of Burton's return and his role immediately upon returning: he returns as a caregiver (not unlike Soon Yi's apparent role in Woody Allen's life). And Taylor is clearly in the role of "woman in distress." Could these roles be a clue to the dynamic of their reconciliation?

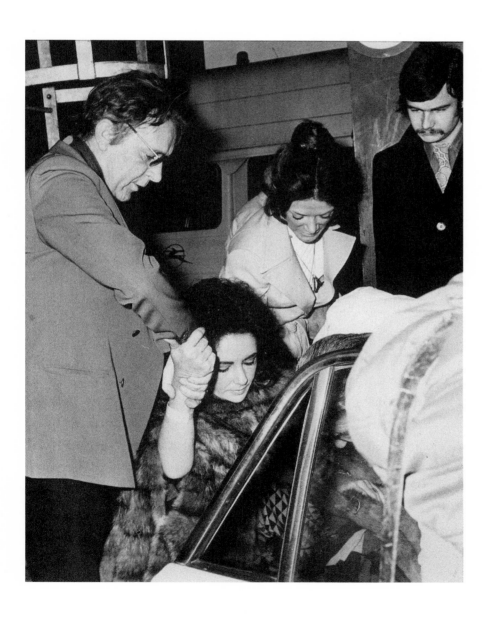

A woman has been injured by a hit-and-run motorcyclist; a passer-by stops, lifts and cradles her in his arms, confers with others on the scene, and subsequently carries the victim to a first-aid station.

The central figure in this candid photograph can instantly be identified as author Ernest Hemingway. Interestingly, Hemingway was one of the first American writers to become a recognizable public figure (in contrast, his contemporary and fellow Nobel Prize winner, William Faulkner, could walk down a crowded street without ever being recognized). And many people say that Hemingway cultivated his public image with the same care as he cultivated his beard—that he was a very vain man. This quality may tempt us to assume that he was a man without fellow-feeling; we think that vanity, especially in a public figure, eclipses heartfelt empathy. Does this photograph contradict that assumption?

..................

Everything about Hemingway's posture and facial expression suggests that he is riveted to the moment, to the crisis at hand. We see it in the rapt attention he gives to the man across from him, who is probably giving him crucial information about where to take the victim. There is nothing at all here to suggest Hemingway's notorious self-consciousness.

Yet there is something about the photograph that gives the author heroic proportions: he is at the center of this drama, he towers over the others in this tableau (the setting is Spain, where people are generally shorter than Americans and Northern Europeans), he displays his physical strength in the ease with which he holds the woman. From Hemingway's novels, we know that he reveres just such heroic characteristics as these. And so, perhaps, he is self-consciously feeling himself to be the hero of this little drama. But does that detract from his *real* compassion, his *real* heroism? I think not.

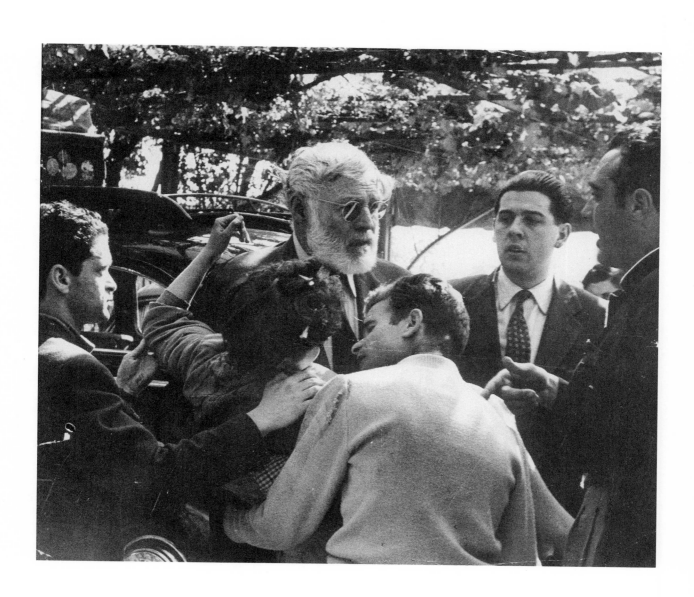

Private Figures, Public Moments

Human photography was transformed into an art form when it began capturing moments in the lives of anonymous people as compared to public figures. Candid shots of ordinary people in characteristic situations not only document their lives and times but speak to us of the quality and the emotional content of these lives.

For example, most of our emotional knowledge of the Great Depression is born of images, as in the artful and compelling Depression photographs of Walker Evans in his famous photo-essay, *"Let Us Now Praise Famous Men."* (The word "famous" was used here for its poignant irony; the people pictured were the very opposite of public figures—anonymous individuals suffering the all-too-ordinary misery of those miserable times.) More powerfully than words (or at least, than words alone), the images urge us to identify with the people in them, to empathize with their predicament, to imagine what it would feel like if we were they at that time, in that situation.

Let us remain for the moment with anonymous images of the Depression and the feelings—many of them extreme—expressed in them. Some of these images became emblematic of the times; that is, the images themselves developed into symbols, a kind of imagistic shorthand for a period of history. Here is one such emblematic image, in fact, a classic.

......................

A man of drastically reduced means sells apples and pears in the street. That the man has seen far better times is broadcast by the way he is dressed, the three-piece suit and bow tie of his former life and employment. (Had he been an executive? Perhaps a banker?) The basic subtext of this image is that the man has adjusted to his new situation in life without any sign of self-pity. Indeed, between the way he has dressed for his new lowly job and the intensity with which he polishes the apple, we sense that he is a proud and noble being. And as such, he is emblematic of the American spirit: *No matter what befalls me, I will prevail!*

But the mere fact that *Undaunted Victim of Depression Proudly Polishes*

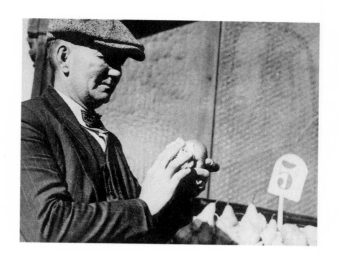

Apples has become an emblem dilutes the impact of this photograph for us. We tend to see it as a generalized symbol standing for the Depression, rather than as an individual at this time and in this particular situation. In short, it drifts toward cliché. Yet we can hardly fault the photographer for this diminished impact.

Or can we? Was this the first image of "Proud Apple Salesman" to come out of the Depression, or was it just another in a long series of predictable, emblematic images? And if it is the latter (as I believe it is), might we also suspect that it was posed? Looking again at the photograph, we are struck by how static the man appears for someone who is supposed to be in the process of polishing an apple—*he* looks frozen, rather than frozen in stop-time by the photograph. Little wonder this photograph has negligible emotional effect on me.

If the subtext of the "Apple Salesman" photograph is the triumph of personal pride over personal suffering, there may be something fraudulent about the image—*it diminishes the actual suffering of Depression victims by suggesting that this suffering can be transcended by good old American pride and nobility.* In a sense, this implies that those who really did suffer did so because they didn't have the pride to rise above it, as if pride itself could quell an empty stomach. This, then, is a subtle form of blaming the victim. As one social historian put it, "Pride is the opiate of the American masses."

Feeling vs. Art

Compare the apple photograph with this Depression image of a young girl and boy pushing a load of firewood along a country road.

........................

Here, too, the principals are frozen in motion, but in this case the movement is clearly genuine. (The dog in midstep is proof positive.) Objects tell much of the story here: the old baby carriage used as a wagon, the ragged clothing (especially the outgrown overalls on the boy), the unpaved, hardscrabble road, and, of course, the load itself—found scraps of wood to keep the home fires burning. The message of these objects is simple and direct: poverty, pure and simple.

The expressions on the children's faces are simple and direct also; they speak loudly in their understatement. Although their eyes are downcast, there is no self-pity evident here, nor is there any fake pride. The boy, especially, looks unhappy, but why should he be otherwise? He is undoubtedly hungry; instead of playing he is working;

and there is a good chance that the emotional tenor of his destination—home—is anything but warm and happy. (Hunger can make the best of parents crabby or worse.) The emotional impact on us, the viewers, is undeniably strong: we sense an entire wretched life here.

Yet, ironically, the one aspect of this photograph that works against its emotional power is its beauty. The arrangement of the figures, including the dog and the makeshift wagon, forms a near-perfect and visually pleasing triangle. The broken-down carriage itself is an aesthetic mix of graceful shapes and compelling textures. And the balance of gray shadings is gratifying. The end effect of this artfulness can be an aesthetic romanticization of poverty and human suffering.

The photographer as artist (even as amateur artist) instinctively tries to make every picture beautiful, just as we, as viewers, are instinctively drawn to beautiful photographs. But the obvious danger is that our aesthetic pleasure may dilute a complete emotional response to the less-than-pleasing human drama we are witnessing. The motion picture *Seven Beauties* is a case in point. For all its horrific realism, this tragicomedy set in a concentration camp was so beautifully photographed—as if painted from an Italian Renaissance palette—that the concentration camp took on a kind of haunting spiritual beauty and that worked against the real horror it was portraying. (Perhaps the title signaled this as an irony, but nonetheless that irony itself diluted the impact of the true human tragedy.)

And so we have one more caveat to keep in mind when we "read" a photograph for its emotional content.

Let us look at another photographic portrait of poverty, this one of Gypsies in England gathering around the pot for dinner. The news story accompanying the photo explains that this Gypsy family has recently been evicted from their caravan site under a new law. This is a fairly routine predicament for Gypsies, but in their case it is compounded by the fact that their horse, Dobbin, is too old and infirm to draw the caravan any longer; they could sell Dobbin for cat's meat in order to afford a new horse, but the family is too attached to Dobbin to do that. Happy ending (just before this photo was taken): the SPA has offered to buy the animal and the Parish Council will also pitch in to buy a new horse.

....................

This is a remarkably happy family portrait. The smiles, especially on the children's faces, appear spontaneous and genuine; the three generations seem comfortably huddled together; they all appear remarkably healthy and handsome, despite their privation. Dinner looks very promising (is the woman in the headscarf smacking her lips?); the laundry on the line in the background looks homey; and the caravans themselves look cozy, if rather small to sleep this number of people. And finally, there is the gesture to include the recently reprieved Dobbin in the family portrait, an act of love and loyalty.

Again, there is clearly something artful about the photograph: the caravans themselves are beautiful objects and, set at corresponding angles behind the huddled family, provide a protective frame; the family is good looking; and the hero of the piece, Dobbin, gives the whole picture a sentimental gloss. What is more, all of this corroborates some of our preconceptions about Gypsies: that they are strong survivors, that they stick by one another, that the life of the open road is hearty and romantic. So does all of this mean that we are misreading the photograph? That perhaps they are not as coherent and happy as they appear here?

I think not, because I sense in this photograph that the *subjects themselves* are the main contributors to its aesthetic. The beauty of the wagons is a legacy of Gypsy culture and the angle they are set at was

surely designed by these people, not the photographer. Their faces seem to reflect who they really are, not some pose of who they or the photographer thinks they should be. If we compare this photograph with "Apple Salesman," I believe we perceive a far subtler, deeper, and more genuine quality of personal pride in the face of adversity.

Context and Meaning

Quiz: What's going on here?
No time limit. But no peeking either.

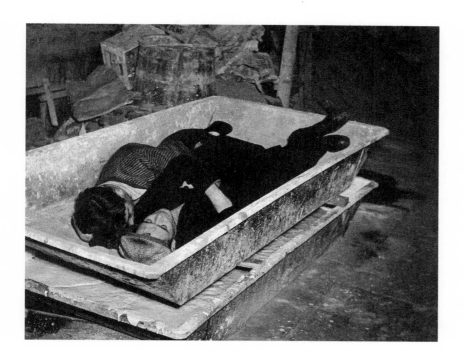

If you guessed that it was two mobster victims of hit men, you would be in the majority of guessers.

You would also be wrong.

If you guessed that it was a pair of dandies who had been out on the town and got so drunk that they lay down for a nap in the nearest "bed" they could find, you would again be making a popular choice and you would again be wrong.

And if you guessed that they were homosexual lovers dozing after a clandestine encounter, you would be wrong yet again. Because what we see here is yet another portrait of poverty: *two homeless men sleeping in the only "bed" they can afford.*

Only by knowing this context can we begin to analyze the photograph for social or psychological content. Just as context is necessary for relevant literary analysis, it is necessary for photo analysis. Otherwise, it is just a guessing game.

Now look again at the photograph.

................

We are struck by their clothes and the condition of the hair of the man on the left: these men do indeed look rather well groomed and handsomely dressed. But knowing the real context of this photograph, this adds to the pathos of the image. Just as in "Apple Salesman," we deduce that these men have seen far better times, that they are wearing the clothes of their former prosperous lives; but unlike "Apple Salesman," we are not asked to believe that they are brave and prideful souls who are undaunted by their misfortune. On the contrary, the juxtaposition of their good clothes and parted hair with the filth and degradation of having to sleep in a mortar trough captures the essence of their condition. There is nothing redeeming about their pose. This is as "down and out" as you can get.

As to the way the two men are huddled together, we assume it is for warmth, but we also attribute some kind of nonsexual intimacy to them. I think this is an appropriate interpretation because huddling together for warmth is *in itself* a kind of intimacy, the per-

force intimacy of necessity: to stay warm, one has to overcome all inhibitions about physical contact, and physical contact is not just a *result* of intimacy but also *promotes* feelings of intimacy. The friendships forged in foxholes are more intimate than those forged at dinner parties.

The Dramatic Extremes

Candid photographs of anonymous people in the throes of ecstatic emotions speak to us loudly, if unsubtly. As I have said, many of us long to experience extreme and dramatic emotions, and seeing photographs of people experiencing them not only verifies the object of our longing (*it's a real emotion, not just one that we have imagined*), but may give us clues on how we can access them ourselves.

People photographed in the throes of religious ecstasy are probably the most popular example of this genre. (One obvious reason we are more likely to see these photographs than, say, photos of people experiencing romantic or sexual ecstasy is that religious ecstasy is much more likely to be expressed in public.)

Here is a photograph of an Iranian devout who has fallen into a swoon at the funeral of the holiest of men, the Ayatollah Khomeini. He is being carried aloft ostensibly to avoid being trampled (there were literally millions at the service).

........................

We are ineluctably drawn to the face of the man in the swoon, but in order to read it well we must turn the photograph upside-down. (Our perceptual-cognitive equipment does not allow us to interpret or, sometimes, even recognize inverted faces.) The man's face appears slack, his mouth agape, his eyes in a frozen stare. He looks shocked, transported, totally oblivious to his physical surroundings or the fact that he is being handed across the top of a teeming crowd. His mind and spirit are clearly someplace else, in another realm. For comparison, when we turn the photo upright again, we see that the other faces, although intent, are in the here-and-now.

I, for one, have ambivalent feelings about achieving such a state of ecstasy. It basically looks just plain frightening to me. Yet I, like many others, am fascinated by it and by this photograph of someone experiencing it. Are those staring eyes viewing something more wonderful than anything we can see in the immanent world?

But the Iranian's experience is founded in a world so foreign to me that perhaps I can more easily identify with someone from the Western World who is in a similar situation. In this photograph, a Roman woman is lost in prayer for the soul of the recently departed Pope John. She is kneeling in St. Peter's Square in the Vatican as the rain pours down.

The power of this image is in the woman's utter solitude. What she is experiencing is obviously intensely personal and private, especially when compared with the sense of mass hysteria we pick up from the photograph of the Khomeini funeral. This quality of solitude is emphasized by the fact that when we usually see images of St. Peter's Square it is packed with spectators and tourists. But not at this moment because it is raining; this woman is praying alone in a downpour, oblivious to it. (This is underlined by the figure in the upper left who is running for cover.) What is more, she is kneeling on the wet and hard stones of the square in what appears to be her "Sunday" dress and shoes, again oblivious to the consequences.

But what can we read on her face? It hardly looks ecstatic in the way the Iranian's did. Rather than slack, it appears drawn and tense; rather than enthralled, it appears devastated; and most significant, rather than staring out at "another world," the downward cast of her eyes and pucker of her brow suggest that she is turning inward. Clearly what she is feeling is private and painful; she is "deep" in mourning.

What we are basically comparing in these two photographs are profound cultural differences: Mideastern religious experience contrasted with Western religious experience. Although they are photographs of individuals, these images are able to convey volumes about the differences between entire cultures.

For a different kind of contrast, let us examine this photograph of a Jehovah's Witness mass baptism on a rugby field near London. Nearly 1,400 people were baptized on this day, at a rate of fifteen per minute. Baptism, in this religion, symbolizes dedication to the movement's work and comes after a long period of instruction. Before being accepted for this immersion ritual (and before changing into a bathing suit), each was asked two questions: "Do you recognize yourself as a sinner needing salvation?" and "Have you dedicated yourself unreservedly to do God's will?" The appropriate answer was, "Yes," to both questions.

........................

To the uninitiated, there might be something almost comical about this scene: Is it a mass swimming lesson? Some kind of ersatz beauty pageant? Even when we know the context, we are struck by the assembly-line nature of the enterprise. The man in the suit coat and name-tag at the top of the pool stairs appears to be intent on keeping the parade going at a steady pace; the male baptizers in the pool are uniformly dressed and, to a man, in motion, reaching for the next inductee; and behind them we see what is probably one of the reasons for the brisk pace—the "audience" in the bleachers. No matter how holy the event, they can't keep watching this forever.

Three individuals stand out for me. First, the old woman in the middle: she's wearing a dress rather than a bathing suit, which seems more becoming to her age; she looks somewhat startled (perhaps by the temperature of the water) and happy, but her expression seems to be saying, *"What a lark!"* as compared to, say, *"What ecstasy to surrender myself to God's will!"* Next, the young woman just behind her just entering the pool: she *is* wearing a bathing suit and it reveals a not unattractive body; the slight tilt of her head, the inquiring look of her eyes, and the demure beginnings of a smile on her lips seem almost coquettish. (In another context of young, muscular men helping a young, attractive woman into the pool, this would be the expected expression for her to have. Is that context poking through from her unconscious?) And finally there is the woman in the foreground with her arms

crossed over her chest, about to take the baptismal plunge: we see apprehension on her face in the strain on her brow, her squint, the slight opening of her mouth, but again this expression seems to be saying, *"This is scary"* rather than, say, *"I am about to take a great spiritual step."*

My interpretations here may be particularly subjective; I admit to being hypercritical of what I perceive to be overly organized religious experiences. And that is why I am much more moved by the experience I feel expressed in the solitary figure at the Vatican than the ones expressed at this mass baptism.

Ecstasy and Movement

After religious ecstasy, the most frequent *public* expressions of this extreme and dramatic emotion are found in physical experiences, usually athletic experiences that combine motion with danger. Athletes and daredevils alike speak of the "high" they feel in the midst of their exploits. They feel totally in the moment, weightless, at one with the world. There is no room in their consciousness for distraction or rumination. They give over their entire being to the action. They *are* ecstatic motion.

In these three photographs, we see young women in the thrall of ecstatic movement.

........................

We are struck by the fluidity of the motion. Rider and horse float over the jump as one—we see it in the symmetrical arches of their backs, in the perfect balance of the rider that shows the force of momentum being exerted equally on both horse and rider. There is no saddle or bridle to mediate between them, making the jump both more dangerous and more intimate.

All we see in the rider's face is her intensity. Is there ecstasy there too? Not an otherworldly, beatific expression of ecstasy. But the rider has, in fact, informed me that that is exactly what she was feeling. The intensity *was* the ecstasy.

"[She] flies through the air with the greatest of ease, the daring young [girl] on the flying trapeze." Indeed, it is the young girl's *ease* that strikes us, an ease born of fearlessness and sheer joy. Looking at her suspended in midair with her head flung back, we can imagine the thrill of seeing the sky swing by through the leaves in this ecstatic, topsy-turvy moment.

Between Ecstasy and Hysteria

Those of us who try to practice a liberal and humanistic form of psychotherapy are frequently confronted with questions of what we consider "healthy" emotional states and what we consider "unhealthy" or dangerous emotional states. A case in point is the distinction between ecstasy and hysteria. I, for one, would not want to discourage anyone from seeking even the extreme ecstatic state that the man mourning Khomeini is experiencing; in some spiritual sense that I do not completely understand, this may be the most significant experience of this man's life and I would never presume to say that it is "unnatural" or "unhealthy" or that it cannot be worth the risk to his physical well-being. On the other hand, hysteria, especially mass hysteria, appears to have little redeeming value while at the same time being potentially dangerous. This distinction may reflect my values more than an objective model of "mental health," but then again, any model of mental health is going to be value-laden.

The two photographs that follow illustrate my fears about mass hysteria. The first is of some Beatles fans at a stadium in Seattle caught in the throes of what was so fittingly called Beatlemania.

..................

Our eyes go immediately to the trio of pubescent girls standing at left center. The one on the extreme left appears to be cheering and applauding, while the two girls next to her are literally overcome with emotion, crying helplessly, the one on the far right extending her arms as if in supplication. Reading their expressions from left to right is like seeing three stages of hysteria—from enthusiasm to weepiness to full-throttled hysteria bordering on a swoon. It is probably no accident that these three are together, not just because of their shared passion for the Beatles, but in their ability to generate mini–mass hysteria—the hysteria flows from one to the other like a contagion. It is interesting to compare these three with the others pictured here, in particular the young man in the lower right-hand corner, who looks more amused than enthralled, and the

matron in the same row on the left, who merely looks skeptical and bemused.

In a sense, the scene looks innocent enough. Pubescent girls have always swooned over big stars; it is simply part of their hormonal/romantic makeup. No danger here. Or is there?

This photo is of the parents of Bernadette Whelan, a young woman who committed suicide because she realized that she could never be united in life with her idol, pop star David Cassidy.

....................

The pain of loss on their faces speaks for itself. But it is Mr. and Mrs. Whelan's brave purpose in posing for this picture *in their late daughter's bedroom*—nay, her *shrine* to the idol she died for—that speaks most loudly. We look at the pictures of Cassidy, his boyishly innocent smile on the right-most poster, his almost feminine beauty in the central poster; and his blatantly sexual pose of hands looped over belt drawing the eye to his groin in the poster behind the father—seductive yet unreachable, every one of them. It is as if the grieving parents have chosen to pose in this setting to say, *"How can this be what she died for? This media-generated nothing!"*

Then we look at the vanity table next to them and its mix of Cassidy images and makeup, a rather extensive array of skin creams, nail polishes, and other cosmetics for a girl just entering her teens,

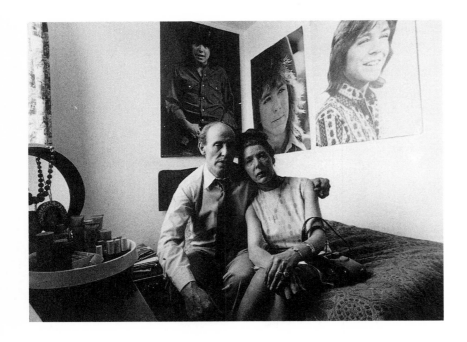

and the tragedy deepens. Bernadette died because she could not be united with Cassidy in life; not all the makeup in the world could make her beautiful enough to be worthy of him. In other words, Cassidy's manufactured unreachableness served to push the girl's low self-esteem to the point of suicidal despair.

Looking back at the parents, we see something awkward in the way the man tries to comfort his disconsolate wife. His closed hand seems to rest tentatively on her shoulder, as if he is afraid to make contact with her. Is it because he senses that she is in such awful pain that even his touch will hurt? Or could it be that his hand is clenched in anger—a fist that says, *"I could kill you for taking my child from me"?*

Obviously, I have stacked the deck here by pairing these photos and that in itself is a lesson in how grouping photographs in a particular way can manipulate the viewer's response. Nonetheless, I stand behind my little manipulation: I really do think there is something "unhealthy" about show-business-produced mass hysteria.

Extreme Emotions at Extreme Moments

Photographs that capture moments of tragedy arouse our sympathy, but can also attract and excite us in ways that may eventually make us feel guilty. *Am I getting off on someone else's misfortune? Does this image excite me because I am not suffering and they are?*

These questions are especially relevant in the current tabloid culture, where hours of prime-time television are devoted to candid sequences of people burning, jumping out of windows, being chased down, etc., all of which caters to our most voyeuristic, crass, and sadistic impulses.

Yet photographs of people in the midst of personal tragedy can also serve noble purposes. They can evoke our compassion (and perhaps prompt us to charitable action). And they can deepen our sense of what it is to be human.

In this photograph, a Croatian teenager is bidding farewell to her father as she leaves on a bus during an evacuation of Sarajevo during the Bosnian crisis. Men between the ages of eighteen and sixty were not permitted to leave the city, so the girl must go without him.

........................

The tragic sadness we see on the daughter's face is deeply moving, but even more moving is the evident love father and daughter feel for each other. There is an infinite sweetness to their parting sorrow, a sense of profound love that appears will stay with both of them despite their awful situation. At a time when the term "family values" has been trivialized by overuse and misuse, it is ennobling to witness family love that transcends tragedy.

There are a few details in this photograph that deepen our emotive response. In the lefthand corner we glimpse a khaki sleeve with an epaulette; the father is standing next to a soldier who is, undoubtedly, carrying a gun. This, in just a patch of imagery, conveys to us everything we need to know about the power that is separating father and daughter.

We note the many layers of clothing the girl is wearing—surely

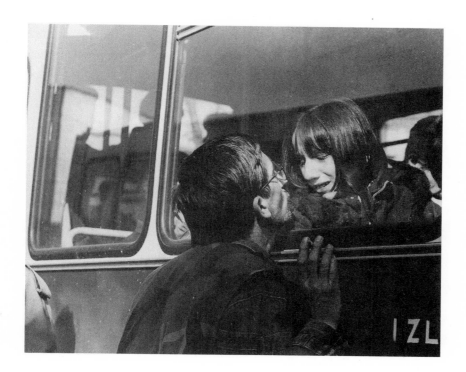

she will be too hot on the long bus ride. But then we realize that she has probably been limited to a single small suitcase and so is carrying as much of her belongings as she can on her back, heat or no. Around her neck is a colorful and tastefully-tied scarf, a sign of feminine pride and self-esteem: *"Don't worry, I won't let them take that away from me, Father."* And finally, looking at the father's grease-covered hand and unshaven face and then at his dampened and carefully-combed hair, we are moved by his clumsy effort to look his best for his daughter as he bids her farewell.

Emotionally connecting with this photograph, I feel proud not only to be a father but to be human.

Here is a photograph of another kind of refugee, four Italian men hiking to safety after a catastrophic landslide that buried their homes and then engendered dangerous airborne infections from the thousands of dead bodies festering in the rubble.

....................

One man holds a handkerchief to his face, either to wipe his tears or to filter the stench of the rotting bodies all around him. (We see rescue soldiers digging corpses from the rubble in the background.) The man to his immediate right presses his palms to his cheeks in shock. This gesture captures my attention for an unusual and interesting reason. "Palms-pressed-to-cheeks" has evolved into gestural shorthand for the emotion/expression of shock; we use this gesture *self-consciously* as a way to signal our alarm or, more often, our mock-alarm: *"Oh me, are you really going to wear that tie?"* we say as we place our hands against our cheeks.

But in this photograph we see the gesture in its spontaneous form, as a reflexive response to horror. There is something primal and childlike about the gesture, as if the horror is too great for the senses to take in and therefore threatens the stability of the main seat of the senses, the head. *In a sense, the man's hands have flown to his head to keep it from exploding with shock!*

Gestures frequently evolve from a spontaneous response to a form of sign language; for example, we pantomime a phony yawn to signal our boredom, while the "original" yawn of boredom was actually an involuntary response. It is a natural evolutionary process, yet it has the unfortunate effect of diluting the emotional impact of the original, spontaneous gesture. When we see the man pressing his palms to his cheeks in horror, the image resonates for many of us with the famous Edvard Munch painting, "The Scream." In that painting, we see a man on a bridge, his mouth open in a perfect "O" as he screams in some deep personal anguish, *his palms pressed to his cheeks.* But this painting has been transformed into a clichéd image by repetition and parody in the popular media. Think Macaulay Culkin pressing his hands to his cheeks in the film *Home Alone* the "Scream" masks in the

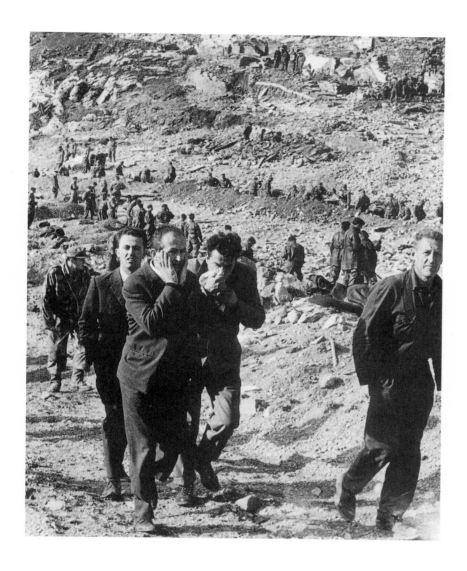

cult horror film of the same name; and greeting card illustrations of the Munchian image with a message that reads, "I missed your birthday!" Thus the original gesture is diluted and trivialized; we lose the ability to empathize with the genuine emotion it once expressed.

But that is exactly why the Italian in this photograph pressing his palms to his cheeks resonates so loudly for me: it reestablishes the power of the spontaneous gesture as compared to its poor relation, the self-conscious gesture. His shock is real, his shock is human. He verifies both the emotion and the spontaneous expression of it for me.

Unexpected Emotions at Extreme Moments

If candid photographs of ordinary people in extreme situations can verify powerful emotions for us, they can also surprise us with unexpected human reactions. And these unexpected reactions can be instructive themselves.

In this photograph, a woman gazes through her roofless home at a passing helicopter. The roof was blown off by another airborne visitor: Hurricane Andrew.

If we look closely at the expression on this woman's face beneath her shielding hands, we see that she is smiling. Indeed, there *is* something comical about having the privacy of your home suddenly revealed by the clean lift-off of your roof, as if your home has abruptly become a dollhouse. And for the moment, at least, this woman seems to be viewing her catastrophe from this comic perspective. *"Crazy, isn't it?"* her bemused expression seems to say. I am reminded of the humorous title of the wonderful opera that John Adams wrote about the most recent San Francisco earthquake, *I Looked Up at the Ceiling and I Saw the Sky.*

What makes this photograph particularly captivating is that we expect to see horror or defeat on a hurricane victim's face, not this. Our surprise leads us to a feeling of inspiration—the human spirit prevails. Perhaps the woman's expression is also saying, *"Hey! I'm still here, aren't I?"*

Emotions Too Big to Feel

We are frequently asked to feel and express emotions on cue. At a funeral, we are expected to feel sorrow and express it in tears, even if we can only genuinely feel that emotion and express it in that way when we are totally alone. And so, out of respect and self-consciousness, we make a valiant effort to summon up these feelings or, at the very least, to portray them convincingly.

In this photograph, we see a class of Israeli kindergartners observing two minutes of silence on Holocaust Remembrance Day.

..................

They are surely an earnest-looking group of youngsters, standing at attention for two full minutes while the sirens wail in memoriam of the six million Jews murdered during World War II. And certainly,

living in Israel, that tragedy is very much present in their culture, a topic never far from any Israeli's mind even fifty-plus years afterward.

But at this particular ritualized moment can any one of these children actually be experiencing anything approaching the enormity of the Holocaust? (The boy with the tousled blond hair is looking at the teacher for a clue on how he should be feeling/acting.) Can even their teacher be feeling the "appropriate" emotion on cue?

Probably not. But, like the private mourner at a public funeral, they are all showing their *respect* for the emotions that are too big for them to feel.

The Fine Line between Sentiment and Sentimentalism

Images of "small" emotional expressions—say, tenderness, loneliness, or amusement—often strike the viewer more directly and affectingly than dramatic images of extreme emotions. They are simply more familiar to our own emotional repertoires and hence easier for us to identify with.

But again, genuine emotional expression can be diluted or eclipsed by clichéd emotional expression, and we may end up feeling emotionally shortchanged. There is a fine line between sentiment and sentimentalism, between spontaneous, heartfelt "small" emotions and self-indulgent, mawkish "small" emotions. For example, the ubiquitous image of the "Smiley Face" (perfect yellow circle, dots for eyes and nose, and a single horizontal arc for the smile itself) does not convey any emotion to me (except, possibly, boredom), despite its insistent message of *"Don't worry, Be happy!"* But the smiles captured in the three photographs below all have the power to let me empathize, to make me smile with them, especially after I know their personal context.

Here, a ten-year-old boy smiles at and chats with a dachshund. He is on the floor of his neighborhood pet shop where he stops after school every day to spend time with the dog. Not permitted to have a dog of his own at home (small apartment, working mother), the boy contents himself with these daily visits. He said he'd call the dog Abraham Lincoln or John Kennedy if it belonged to him. "They did something for their country," just as the dachshund is doing something for the boy.

........................

The boy's eyes tell it all: they look directly into the dog's eyes, a connection between equals. There is no doubt that, at least from the boy's point of view, these two are friends. The boy's relaxed pose, his open-mouthed smile, his facial expression of warmth and contentment allow us to easily enter into his emotions.

There is also something comical about the picture. The breed of the dog is itself a bit of a joke—compared to the torsos of most four-legged animals, his looks "stretched," a waddling hot dog. But add to this the bend of his neck caused by the way the boy is holding him and the image seems even more humorous. Does this comic cuteness push the image over the top into the realm of sentimentality?

Not for me, especially knowing the story behind it.

Images of children and animals (and particularly children with animals) can all too easily evoke standard sentimentalized responses from us. They are the stuff of mushy greeting cards and maudlin calendars. And that, again, is why it is so refreshing to connect with the genuine article.

Here is a photograph of an entire gallery of smiles. There is nothing particularly remarkable here until we know the story behind it: it is an entire soccer team of *brothers,* including the coach and a substitute; the man at the extreme left is the father of them all.

..................

Knowing the relationship of these men makes looking at their faces fun, particularly so because family resemblance seems to be most reflected in their smiles: Dad's toothless version is pretty much replicated across the board.

However, there are a few interesting exceptions, all in the righthand side of the photo. The two sons seated at that end of the bench do not appear to find this whole family soccer team business quite the lark that the others do. The one on the extreme right looks unsmilingly into the camera with an expression that suggests that he is reluctant to be here; and the brother next to him, also unsmiling, is looking away from the camera—clearly something more interesting has caught his attention. And the brother standing just behind him (second from right) looks as if it is taking considerable effort to produce a smile for the camera; there is something in the cast of his eyes that suggests he may be the melancholy brother in this brood. (It is probably no coincidence that all three of these exceptions have placed themselves in the same area, farthest from both the camera and their father.)

For the viewer, the three brothers who do *not* appear to be caught up in the convivial family spirit give the photograph authenticity; by contrast, the smiling brothers apparently really do feel that this whole family enterprise is a blast.

Here is another family with a quirky story behind it. The couple kissing are newlyweds, the children in front of them products of earlier marriages by both. Nothing out of the ordinary so far. But it so happens that these two got together after their respective former spouses ran off with each other on a recent Christmas Day.

....................

Happy ending, it seems. The wedding couple themselves certainly appear to be happy and in love. But I am less convinced of a "happily-ever-after" scenario for the children as they are pictured here. In particular, I am struck by the expressions of the two littlest girls in front. The one on the left appears hesitant, even a bit apprehensive. Is it just for the moment or does she already sense the complicated adjustments awaiting her? The tiny girl front and center hits me even harder. Her smile is about as "put on" as a smile can get, the very essence of what we call a "brave" smile: she is putting it on *in spite of* her real feelings. And that is what makes it all the more affecting for the viewer. Do we even glimpse her real feelings in the squint of her eyes? If you were told that in the next moment she burst into tears, would you be surprised?

Here is a "good time" photograph with a tragic subtext that only becomes apparent when we know the story behind it. I will save that story until after we have given the photo a first look.

·····················

Ah, the '60s! Student high jinks! A pile of fifty young people on a single bed! Innocent fun!

But looking at individual faces, we immediately see that the smiles increase in mirthfulness the higher up on the pyramid they are. Toward the visible bottom, they start to look grim and grimmer, especially the lad on the left who appears to be grimacing. We surmise that it's not quite so much fun being on the bottom.

The real story is far worse than "not quite so much fun being on the bottom." In fact, one student at the bottom, buried under four tons of humanity, was crushed to death. Knowing this, let us look at the photograph again.

·····················

Look at the boy in the center of the photograph with a young woman sprawled against him. He smiles boyishly and openly for the camera, *"Hey, you think I'm a screwball, but I'm having a ball!"*

Now look at his right hand bracing himself on an anonymous ankle. The rest of the person that this ankle is attached to is submerged in the human pile, just as all the exposed shoe soles belong to bodies buried under the weight of other bodies.

Is the boy totally oblivious to this fact? Does he even care or does the thrill of the moment make this fact inconsequential?

The boy's smile does not look so boyishly innocent now.

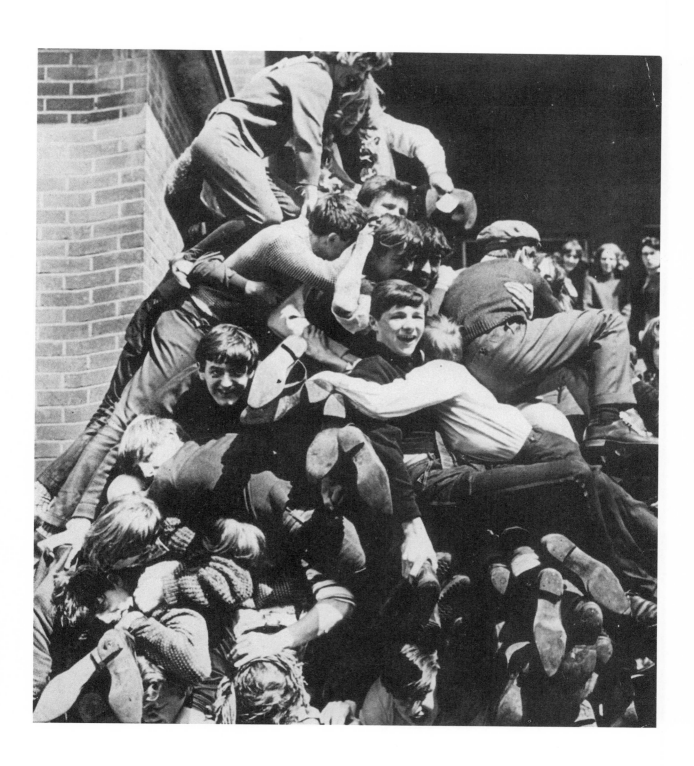

Small Events, Big Emotions

One of the ways families remember the ups and downs of a vacation is through the pictures they take. Someone I know showed me this photograph as a graphic illustration of a bad start to what turned out to be a great trip.

The situation was simple and rather typical: the car had broken down, and the family had to wait while the father sought out a rental.

....................

Oh, what a portrait of resignation and dejection, especially in the faces and poses of the mother and daughter. (Only the son, with his ever-ready video game, seems to be enduring the setback with equanimity.) They are hot, for sure—note the bright sky and desert cacti reflected in the window. Do the reactions of mother and daughter seem out of proportion to the circumstances? Small events do have a way of triggering powerful emotions, because at the time they seem much larger than they are. But knowing the family, I suspect there was also some hamming it up for the photographer.

Chapter 4

Power

According to most social historians, the human relationship that most determines the course of history is *power*. A great many of my fellow psychoanalysts (particularly Adlerians) agree: more than love, sexuality, or devotion to ideals, power or the will to power is the human animal's prime mover.

Whether or not this is true, the importance of power in relationships cannot be underrated. And the questions it raises are endlessly interesting: *Who's got power? Who doesn't? And what accounts for who has it and who doesn't?* (Hint: it's not always money, social standing, or official authority.)

I have always been amazed by the capacity of photographs to capture the essence of power. We not only have an opportunity to analyze facial and body expressions in stop-time for signs of power, but we can study the way the relative postures of figures display power in a particular relationship.

Powerful Personalities

One answer to the question of why some people have power while some do not lies in that all-purpose abstraction, *personality*. Whether a result of their upbringing, their genetic makeup, or their physical stature (or all three and a few other things too), some personalities are clearly more powerful than others. We experience it in the way these powerful personalities speak, what they expect of themselves and of others, and in their manifest confidence. But before all that, the power of their personalities speaks to us loudly in their expressions and postures.

In this photograph, we see two "officially" very powerful men, Richard Nixon and Lyndon Johnson. The occasion is the official transfer of presidential power from one to the other: Nixon is president-elect, Johnson is in the last months of his one-term presidency, having declined to run for a second term after his failure to bring the Vietnam War to a close. Under the circumstances, one would expect to sense more power emanating from Nixon than from Johnson—after all, Nixon is the one about to assume the most powerful position in the Free World, while Johnson is about to relinquish his office in the context of failure.

....................

There is not a scintilla of doubt about it: the most powerful personality pictured here belongs to the man on the right, Lyndon Johnson. Everything about him exudes it: the open stance of his legs suggests fearless confidence, a man who does not have to protect himself or hold himself in; both of his hands suggest that he is a man with a "firm grip" on things, nothing tentative here; and the way he sits in a straight-backed chair that literally elevates him above the already-shorter Nixon probably reflects a choice that the power-conscious Johnson has made (*"Here, Dick, take the more comfortable seat, please"*). And finally, we see power in Johnson's face, not a pretty face to be sure, but nothing soft or yielding about it: it's solid as granite.

Richard Nixon appears to be the virtual opposite in every way: there is something almost feminine in the way he sits back in the sofa with

legs crossed emphasizing the girth of his hips—it is a protected, held-in pose that looks somewhat uncomfortable, as if he is precariously balanced on one cheek of his buttocks; his hand holding the book (the manual on the transition of power) at the edge with his fingers at an angle suggests more pose than utility—clearly it is Johnson's grip that is bearing the book's weight. But it is the gesture of Nixon's other hand and the puckered seriousness of his brow and stare that are quintessentially Nixonian: there is something forced about them, the gestures of a man who is "acting" powerful rather than casually and confidently exuding it the way Johnson is. Nixon's seemingly exaggerated gestures coupled with his flaccid cheeks and fragile-looking jaw reinforce our image of him as the Eternal Compensator, a "Wizard of Oz"— a small and weak man who attempts to broadcast a sense of power and confidence that he does not really own.

In a period of American social history when women are assuming positions of power in business and government, it is interesting to see what images of female powerful personalities play in the public world.

Here is the first female Attorney General, Janet Reno, flanked by a quartet of all-male Justice Department lawyers, as she launches the Federal antitrust suit against Microsoft.

......................

Look at that short haircut and straight-combed part—it is remarkably similar to the way the men around her (excepting the bald one) wear their hair. Check out that forward-jutting jaw and that flinty squint of her eyes. Alas, Ms. Reno exudes *masculine* power. She may be wearing earrings and a pearl necklace, but their jarring incongruity on this mannish figure only serves to emphasize its mannishness.

Are we to conclude from this that a woman with a powerful personality must, perforce, have a masculine personality? Do we automatically equate feminine personality traits with delicacy and fragility—with weakness? Surely it must be possible to exude both femininity and power that is not merely sexual power. It will be interesting to see the images of female powerful personalities as they develop in the coming decades.

I cannot resist pairing the image of Attorney General Reno with the object of her ferocious lawsuit, Bill Gates, the founder and chairman of Microsoft. A Harvard dropout, Gates is currently the wealthiest man in the world. In this photograph, he is addressing a European audience on Microsoft's ongoing competition with IBM and Sun Microsystems.

<div align="center">......................</div>

There is definitely something comical about the image of this classically "nerdy"-looking man magnified a hundredfold on a screen right next to him. Talk about the "Wizard of Oz!"

Gates's face is soft, nondescript; his eyes look diffident, almost frightened; his haircut looks boyish; his upturned palms seem to signal wariness. Does this define the personality of the self-made wealthiest man in the world?

No, it is the *magnified* image that does! Gates is a canny and supremely ambitious man: the magnified image of himself is the message itself: *"See! Technology is the key to power. Technology can make the most ordinary of men into the biggest man in the world!"*

Let's try some guesswork again.

Do you recognize anyone in this 1915 photograph? Does any one in this trio of soldiers suggest a man with a powerful personality?

To the latter question, we would probably guess the man in the middle. The mere fact that he *is* in the middle suggests that he is the main man: the two men flanking him with their arms around his shoulders lead us to believe that they defer to him. Also, there is a Johnson-like casual confidence to the man-in-the-middle's pose: one hand in pocket, the other resting solidly on the tree stump. And the set of his jaw, his strong, even features, and his earnest stare all suggest a leader—maybe even a man with a sense of destiny.

Perhaps at this time and in this group, the man in the middle *was* the main man. But in less than two decades from this time, the man with the moustache behind him would be one of the most powerful men of the twentieth century, a man with a profound sense of destiny, Adolf Hitler.

Hitler and the other two men were rather lowly dispatch messengers in the German army in World War I. Hitler later wrote that it was during this period that he was transformed from a vagrant, failed artist to a passionate political activist. At the moment captured in the photograph, however, Hitler's principal preoccupation was the dog lying at his feet. Named (by him) "Foxl," the dog had strayed across enemy lines and became young Hitler's boon companion. A fellow messenger remembered Hitler saying, "I like Foxl so much—he only obeys me."

Do this anecdote and Hitler's face and pose suggest a super-powerful personality in the making? Let's look at the photograph again, knowing who the man with the moustache turned out to be.

........................

The man with the moustache looks thin and gaunt, a weak physique with stooping shoulders. The moustache itself has an almost comic appearance, upturned while his mouth is tense and downturned—the double-message of a frowning clown made up with a smiling face. The hooded eyes look sleepy, the eyes of a tired and weakened man, and they appear soulful too. (Is there a hint of tender feelings for his beloved, obedient Foxl here?) His eyebrows are slightly raised, giving

him a look of uncertainty. And, as noted before, his position with respect to the man in the middle is decidedly deferential.

Do we see the seeds of power in this face and pose? I think not. If anything, I see an estranged, somewhat romantic figure, the "artist" he still thought himself to be at this point. If there are any intimations of power here, they are of an extremely subtle and convoluted nature: *it is said that there is no one more vicious than a failed romantic.*

Compare the image of the young Hitler with this one of the Führer leading a triumphant walk through the heart of Paris after the Nazis defeated France in World War II. Now *he* is the man in the middle, definitely front and center—the Commander of the Axis Powers. We know that at this moment his power was absolute and seemingly unstoppable. But does the image itself convey a powerful personality?

Granted, it is difficult to make out much of Hitler's face in this photograph, although it is all we need to recognize him: the little brush moustache, the darkness of and around the eyes. But it is his posture and gait that strike me: this is not at all a convincing image of a powerful man. Compare Hitler's pose with that of the man to his immediate left: Hitler's arms hang stiffly, almost awkwardly at his side, the posture of a shy student forced to stand in front of the class, while the arms of the man next to him are loose and long, with an apparent purposeful swing to them; Hitler's coat is stretched over his torso, making him look small-chested and slightly paunchy, while the coat on the man next to him seems tailored, pinched at the waist and flared at the chest to give him a look of masculine power. And finally, let's examine what we can of Hitler's face: perhaps I am overly influenced by Charlie Chaplin's parody of Hitler in the prophetic comedy classic *The Great Dictator*, but the face I see in this photograph looks more befuddled than virile, more comic than purposeful. (The way the little moustache shortens his face, giving it a pinched, mousy look contributes to this comic aspect.)

So, no, I do not see a powerful personality here any more than I saw in the earlier photograph. In fact, I sense Hitler's abiding awkwardness and solitariness equally in both pictures.

What, then, does this analysis tell us? That photoanalysis and body language analysis are totally undependable? No, it simply shows that power and its manifestations are often much more complicated phenomena than the direct and unsubtle expressions of it in, say, the photograph of Lyndon Johnson. We know about Hitler's power (just as we know about Nixon's) and so, when we search in his images for the motive/source of this power, we have to look for the psychological seeds of it. Yes, Hitler was often an awkward, comic figure and undoubtedly he knew that. And so we may guess that his formidable will to power was a way of combating this evident natural weakness— *his way of forcing us not to believe our eyes.*

For contrast, let us look again at men whose powerful personalities seem to shine unfiltered from their very core. Fittingly, let us start with General Charles de Gaulle, the resistance fighter who led the liberation of Paris from the Nazis, here leading a triumphant, memorial march on the thirtieth anniversary of that victory.

Front and center, perfectly erect and towering over everyone around him, de Gaulle is power, pride, and confidence incarnate. We see it in the assurance of his stride, the upward tilt of his finely chiseled head as he looks out at the crowd accepting (*not asking for*) their admiration. And most evidently, we see it in the gesture of his arms and hands. It is a gesture meant to rouse the onlookers (a gesture that today's NBA stars overuse to get the crowd cheering). And it is also a gesture of supreme vanity—both hands frame and point to his head: *"Me! I am your hero!"*

Only a truly powerful personality would dare such a vain pose and gesture—because only a truly powerful personality could carry it off without appearing to be a fool.

Here we see another powerful political leader accepting the cheers of the masses. It is Mao Tse-Tung, leader of the Cultural Revolution and founder of the People's Republic of China, the most populous country in the world. He stands front and center in the back of an open car along with members of the Red Guard.

........................

Again, we are struck—and somewhat mystified—by the cultural differences between East and West as exemplified by the expression on Mao's face as compared to de Gaulle's. Certainly, Mao looks formidable and solid in the way he stands perfectly upright, his hands resting easily on the rail. But the eyes on his upturned face do not even attempt to make contact with the crowd; on the contrary, he appears to be serenely staring off into the middle distance, a gaze that seems to say, *"I am looking to the future. I am a man of vision!"* And that visionary quality is, of course, the prime source of his political power.

Here is a somewhat uncharacteristic shot of one of the most powerful personalities in show business, the late Frank Sinatra. What's going on here? Hazard a guess.

........................

There is clearly a look of apprehension in Sinatra's eyes, a reluctance to budge evident in his stance vis-à-vis the men on either side of him who appear to be dragging him away. At this particular moment, the superstar's vaunted grace and agility are nowhere in sight; on the contrary, he appears gracelessly off balance. What is happening to Old Blue Eyes?

Most people guess that Sinatra is being forcibly escorted away from one of his infamous brawls with the paparazzi, that the reluctance on his face is saying, *"Just one more punch—that's all I want!"*

Close, but not right. What is actually going on is that Sinatra's bodyguards are starting to pull the star through the gauntlet of paparazzi and fans that stand between him and the Royal Festival Hall in London where he is to perform that night. Like most performers, Sinatra has an ambivalent relationship with his idolizing fans: they are both the source of his power and the source of extreme discomfort. For all his power, he is a man of small physical stature, a man who could be easily crushed by a crowd.

It is interesting again to note the headline that the wire service appended to this photograph: "The Man with the World on a String." This is, of course, a reference to the lyric of one of Sinatra's hits, but in the context of this photograph it is a decidedly ironic commentary: the man with the world on a string looks petrified by what awaits him at the other end of that string.

Unassuming Power

Perhaps the most commanding images of powerful personalities are the most understated ones, the portraits of unassuming power. Let us start with an extreme example: the holy man and political activist, Mahatma Gandhi, spinning cotton.

......................

The message is the glory of the simple, solitary, inward life. In Gandhi's philosophy, this is the prime source of power, including, paradoxically, political power: nonviolent civil disobedience begins with the unflappable serenity of inner contentment.

Here, then, Gandhi is a living embodiment of his philosophy. He is alone, sitting on a hard surface in a small, unadorned, cell-like room, totally absorbed in the simple task of spinning cotton. He is thin (a sign of personal denial) and he wears a single, unstitched length of white cloth as his only garment.

But hold on! We know that he is not *actually* alone: he must be cognizant of the photographer taking this picture. Indeed, he is *posing* for him. Undoubtedly, his message is sincere, but Gandhi knows that to spread the word he must advertise—he must send his inwardness *out* to the world.

The power of Gandhi's personality, then, resided not only in his inner peace, but also in his canniness to reach outward. He was, after all, a powerful leader.

Here is a portrait of unassuming power that appears to me less studied than Gandhi's. It is, fittingly, of one of Gandhi's greatest modern disciples, Martin Luther King, here in a planning meeting with other well-known powerful personalities: Andrew Young, King's assistant and future mayor of Atlanta; the film director Jules Dassin; his daughter Julie; his wife, the international actress and future Minister of Arts in Greece, Melina Mercouri; and the popular singer Harry Belafonte.

Serious, sober business going on here. We see from the empty cups and glasses that this meeting has been in progress for some time before the photographer took the shot. All the faces appear tired, yet almost all are fixed on their leader, Dr. King. His face looks serious, but relaxed, his hand gesture firm but nonaggressive. Like Gandhi, the evident source of King's celebrated power was in his serene inner conviction—the charisma of a man who carries his heartfelt dedication on his face as well as in his words. But unlike the Gandhi shot, what appears important here is what's going on between the people, not posing for the camera.

Here is a candid shot of another powerful political leader renowned for his quiet charisma, Nelson Mandela, at the time the newly elected president of South Africa. With him is Deputy President F. W. de Klerk, on the occasion of the passage of the new constitution.

....................

I cannot view any image of Mandela without thinking that here is a man who spent *most of his adult life in prison* as a political prisoner for his actions against Apartheid. How, then, can he seem so unreservedly joyful? The answer, of course, is because his ideas of justice have triumphed in the end. The entire purpose of his life has been vindicated and that has made everything he has suffered worth it. Again, what we are seeing is the quietly powerful personality of a man of total conviction.

Outgoing president F. W. de Klerk is also a man of conviction. A year after being sworn in as acting president of South Africa, he had the courage to release Mandela from prison as part of his plan to dismantle the Apartheid system. Then, in 1993, Mandela and de Klerk jointly won the Nobel Peace Prize.

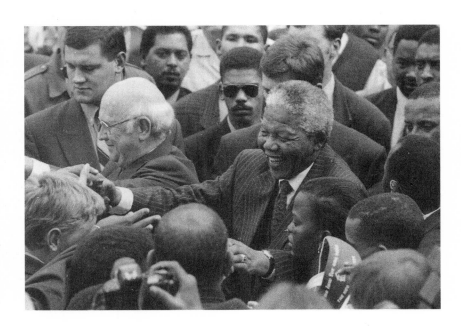

The next photograph was taken as the leaders greet the crowds of people after the inauguration ceremony. Mandela is now president of South Africa and de Klerk deputy president.

.....................

The two leaders raise their united hands up high in triumph. They have accomplished what had seemed impossible. Mandela's face glows with joy, his smile broad and true. De Klerk's face does not show the same enthusiasm. He's pleased, but his smile is contained, his lips sealed.

Compare their faces with the previous photo, and you see how consistent their expressions are. Does the contrast in their faces reflect the differences in how they embrace the political changes that have transpired or the differences in their personalities? Perhaps both play a part.

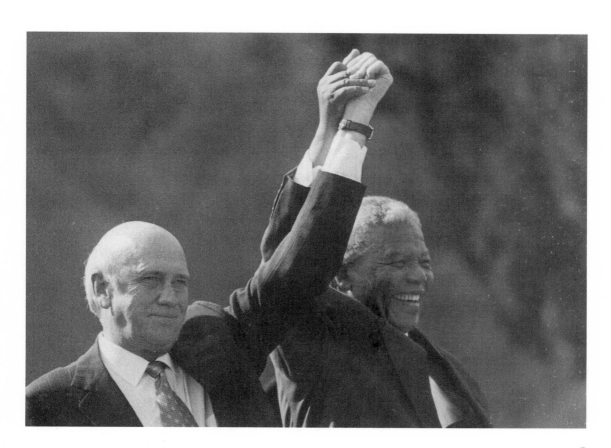

Power in Action

When a photograph captures and freezes power in action, it often can speak more loudly than a motion picture/video sequence of power in action. The photograph says, *"This is the moment that says it all. This is what power looks like."*

Here is my all-time favorite of this genre: a lone Beijing citizen blocks an entire convoy of tanks as they move down the Avenue of Eternal Peace toward Tiananmen Square, where a riot that had already cost several protestors their lives is still in progress. One logistic note: the convoy had tried simply to pass the man by moving to the left (note the arc of the tanks' path), but the man, far more agile than a lumbering tank, had simply moved to block their new route. Then the protester climbed up on the lead tank to try to reason with the crew.

......................

Again, we are viewing the power of one man's conviction, but this time that conviction is in action—an action that involves serious risk. We cannot make out much about the man himself except that his pose appears anything but aggressive. (It looks like he is carrying his shopping, for Heaven's sake!)

The power of this man is conveyed in the entire image rather than in the face or gesture of the individual: A tiny figure brings the huge machinery of oppression to a grinding halt. It has a David and Goliath quality that thrills and inspires.

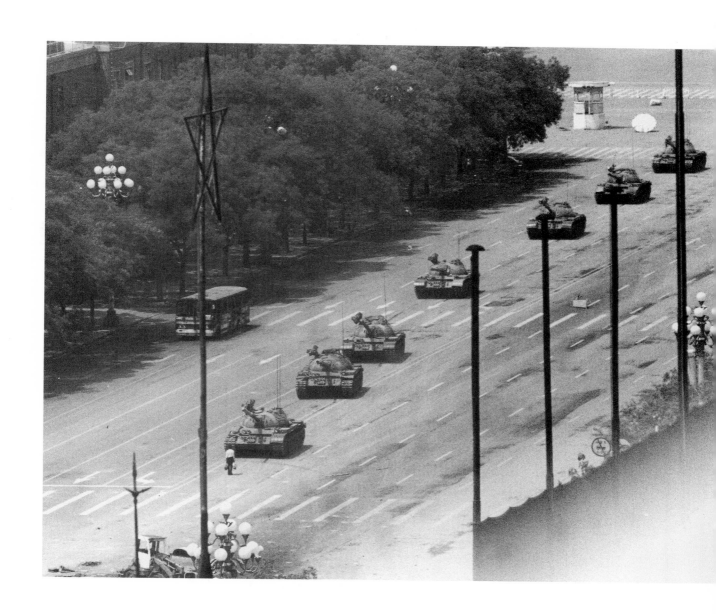

Here we see another protester, apparently more frightened but no less brave. A Vietnam War demonstrator is being forcibly hustled away by a policeman in front of Grand Central Station in New York City in 1969.

....................

Here the power has clearly shifted to the man in the uniform, the man with nightstick and gun. There is an expression of pleading in the young woman's eyes—pleading and perhaps shock—while the cop stares straight ahead, all business, doing his job.

But is that *all* he is doing?

Examine the hands of these two figures. Hers are raised in a protective gesture, but what exactly is she protecting? Her hands are clutched at the level of her bosom. Now look at the policeman's hands. The one at her back, carrying his nightstick, propels his quarry forward. But his other hand is clutching her jacket, clearly making contact with her left breast. It looks like far more than "official" power—it looks like masculine power of sexual abuse!

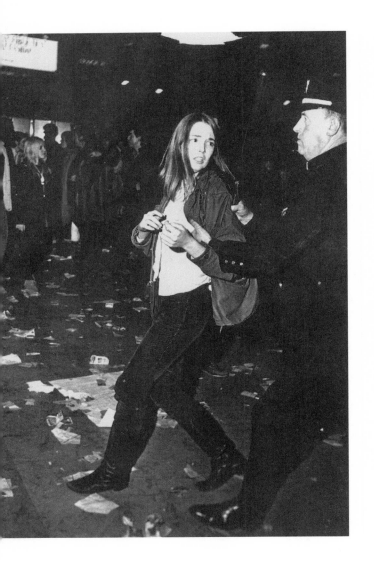

Once again the caption that the wire service attached to this image is telling: "New York Hippie, participating in demonstration at Grand Central Station." The choice of the word "hippie" is well calculated; in those years it was a code word for, among other things, "wanton sexuality." Is the choice of words in the caption an explanation/excuse for the policeman's wandering hand?

It is interesting to compare the last photograph with the next. The scene is also New York City in the late '60s; it also involves an anti-war demonstration, in this case a counterdemonstration; and it also involves the interaction of a man and a woman.

........................

For all the aggressiveness of the man's poster with its macho language and dramatic image of a wounded soldier, the real story here is found on the man's face. His smile is tentative, a trifle shy—anything but macho and aggressive. And his eyes appear to be trying to make contact with the young woman. She does not appear to be an active protestor herself, just a passing student, notebook in hand, yet she is looking in his direction. Is she looking at the poster or the man? We detect the hint of a smile on her profile. Perhaps the real message here has nothing to do with war and protest, but about the eternal dance of the sexes. *"Are you interested? Would you like a cup of coffee?"*

But we see another possible interpretation of the young woman's smile in the poster itself: clearly the man started to spell "REAL" "R . . . A . . . " And the young woman is, after all, a student. She may very well be thinking, *"What a dummy!"*

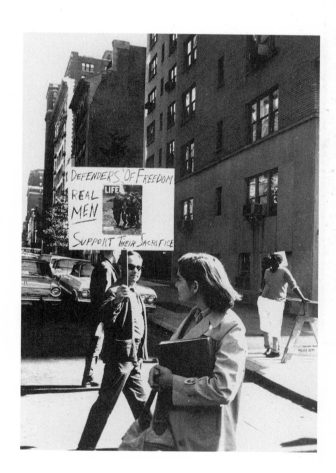

Finally, let us return to that icon of power, Michael Jordan, with a demonstration of that power in action.

........................

Mouth open, tongue characteristically lolling against his lip, eyes fixed intently on the goal, body suspended in midair and leaning precariously backward to avoid any defensive interference, Jordan is doing what he does best: shooting a basketball. His agility is incomparable, his ability to "hang" in the air defies the laws of gravity, and his fearless intensity is uncompromising. His power is more than physical; it is superhuman.

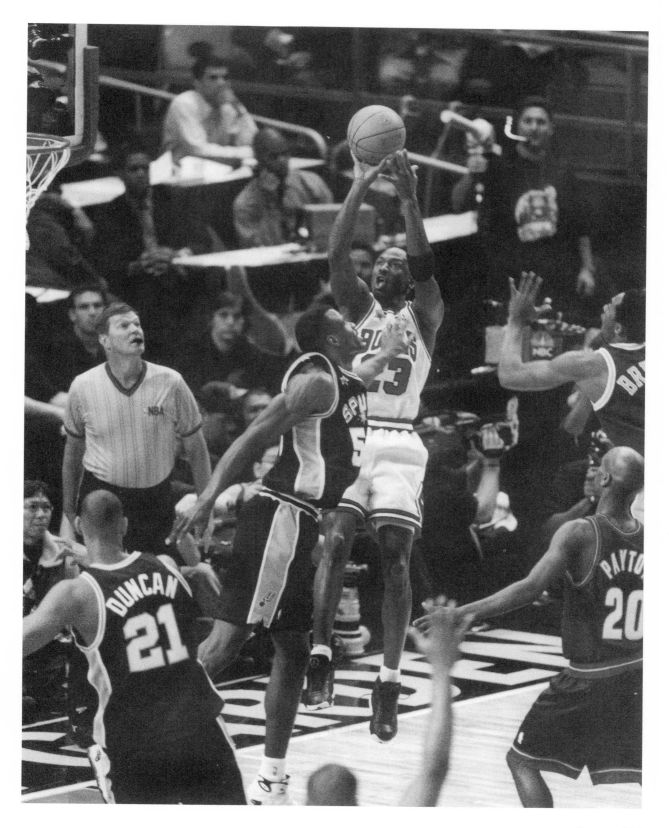

Power in Personal Relationships

Candid family photographs have an uncanny capacity for capturing the relative power in a relationship. The entire dynamic of a relationship can be reduced to a single image that seems to say it all.

In this photograph of an "Old World" couple, friends of my family, I see the whole power structure of their relationship, even though the photograph is posed.

........................

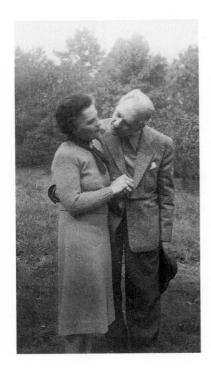

She looks demure, he looks attentive. Their dress seems rather formal for the outdoor setting (especially his coat, tie, and hat), but that only adds to the "Old World" charm. But what power structure is evident in this snapshot?

Let us begin by noting the man's hand at his wife's back—it looks more like he has a "firm grip" on her than that it is a tender gesture. Next, note the tilt of his head as he looks in her face; at first reading this looked merely attentive, but at second look it appears solicitous . . . solicitous bordering on patronizing. The husband has clearly cast himself in the superior role, helping her to stand erect (as if she needed it), leaning patiently down to her level as if she were a child.

The wife's gestures are also telling: she clasps her hands together, but is this a gesture of diffidence or self-containment, a willful holding back that is also evident in the way she holds her head away from his? And perhaps there is a hint of irony in the face she presents to him, as if to say, *"I'll play your little game, but we both know very well that I can stand my ground."*

Finally, let us examine another old photo album snapshot for a story of power. This is a "gag" shot of a group at the beach, four young women and a young man who is lying on their collective lap.

⋯⋯⋯⋯⋯⋯

The pose itself is a kind of ironic play on male superiority: the man wants to lie down, so the women make themselves into a bed for him. (The implication of a "bed" is itself risqué for the times—note the modest, ankle-length dresses the women wear for this summertime beach stroll.) The man's hands folded self-satisfiedly at his waist and his mock-haughty facial expression complete the joke: "I am the king and these are my servile ladies."

But there is one exception: the woman on the far right has somehow maneuvered herself out of this servile situation—the man's head cannot reach her lap. And her arms are raised in a joking gesture of her own, a gesture of carefree liberation, *"Not me! I won't even* play *at being subordinate."*

Postscript: Some time after examining this photograph, I learned that the woman on the far right was the only woman of this group whom the man fancied. In fact, he had a serious crush on her that was never reciprocated. Those many years later, the man in question said to me, "I should have paid more attention to this photograph—it could have spared me a lot of pain."

Chapter 5

The Power of Seduction

Seductiveness is, of course, a species of power, but it is so widely represented in photographic literature that it deserves a chapter of its own. Here again we see the uncanny capacity of still photography not only to capture moments of seduction but also to distill the essence of seduction—to isolate those images of expressions, gestures, and poses that embody it.

We'll start with the most obvious form of seduction—sexual seduction. But from there we will go on to its subtler—and often more powerful—varieties.

Sexual Seduction

We view sexually seductive images daily in advertisements that suggest that if we buy, say, this brand of vodka or that brand of automobile, we will also magically acquire the leggy blond who appears

alongside the product. This message is neither subtle nor unsubtle, it is simply a preposterous association: we see the car and the blond together in the photograph, so at some simplistic level of consciousness we feel that if we buy the one, we get the other.

The obviousness of the sexual come-on in ads and publicity shots has increased exponentially in the past three decades, so it is interesting to begin with a seductive shot from the late '60s, at the beginning of America's so-called Sexual Revolution.

In this 1966 news/publicity shot, two showgirls from the nightclub the Latin Quarter (named after the district in Paris where the "naughty" Folies-Begère performs), display their picket signs protesting unfair employment practices.

.....................

Of course, the pickets are not all these showgirls are displaying. By exposing their calves (and employing the old trick of extending the toe to exaggerate the length and muscular definition of those calves), the young women are plying the seductive message: "If you buy our product (in this case, honor our protest), you will get the girl." However, this is one situation where that message is at least in part true: if the viewer honors their protest (and the women consequently win against their employers), then the viewer will get to see the girls' legs—and much more—at the Latin Quarter.

What I find most fascinating about this photograph is the relative innocence of the pose in the context of today's blatant images of female sexiness. For one, we don't see above their knees—just ankles and calves. Their dresses and coats are anything but tawdry—in fact, they look very Fifth-Avenue fashionable. And the expressions on their faces—particularly on the young woman on the left—is of the fresh-faced, girl-next-door variety. (The woman on the right casts a more personal—and hence, seductive—eye toward the camera, a hint of a promise of intimacy.)

Yet for all the relative innocence of their pose, it is "scandalous" enough to elicit a disapproving glance from the white-haired woman just behind them. Ah, what a difference a few decades make.

Here is another pair of fresh-faced, fashionably dressed beauties from the same era as in the above photo. Guess what is going on here:

A fashion show?

Two women helping each other get ready for a cotillion, one rolling the elbow-length gloves onto the other?

Answer: They are strippers at the beginning of their act, one rolling *off* the elbow-length glove of the other.

We are struck again by the classiness of these two purveyors of sexual seduction. Their identical, modestly cut dresses and jewelry do indeed seem the stuff of cotillions rather than of the burlesque house runway. The same can be said of their hairdos and makeup. The fine-featured delicacy of the face of the woman on the left also bespeaks class, while there is a touch of the cupie doll in the open mouth and wayward eyes of the woman on the right. But neither appears tawdry or cheap or whorish.

This very classiness was once the key to a seductive striptease: the aristocratic-looking woman is transformed into an accessible sex object by stripping away her respectable clothing (or, put another way, by stripping away her "clothing of respectability"). In Freudian terms, the untouchable "madonna" becomes the willing-to-please "whore," resolving a fundamental male sexual ambivalence before men's eyes.

Much of the power of this particular kind of sexual seductiveness has been lost in a culture that *begins* with an image of nudity and lewdness: it has nowhere to go.

And here is the ur-image of classy feminine sexual seductiveness, the German actress and singer, Marlene Dietrich, seen here serenading American troops during World War II.

....................

Dietrich manages to bridge the gap between untouchable class and easy availability in a single image. Her refined features and delicate bone structure exude good breeding, while her silky, nightgown-like, loosely-tied robe (*"How easily this could be removed in a single pull,"* we think) suggests immediately accessible sex. Her long-fingered hands say, *"Class,"* while her open arms say, *"I'm yours for the taking."* And finally there is her classically beautiful face with its hooded eyes and ever-present look of both disdain and neediness, jadedness and warmth. Dietrich's image represented classic seductiveness in her time. Indeed, in real life she was a renowned and very "democratic" seductress.

What could be more seductive than Marlene? Only one thing, according to this photograph: *personal vanity.* One man pictured here could resist gaping at the sexy star—because he was seduced by the camera itself, by the prospect of seeing his *own* image captured in black and white.

It is interesting to compare Dietrich's style of sexiness of the mid-twentieth century with Princess Di's style of sexiness near the end of the century.

......................

Lovely and "royal" as the princess is, she lacks the fine-featured classiness of Miss Dietrich—she is far too big and athletic-looking (note the impressive musculature of her exposed calf) to carry off that image.

Turning to the "seductivity quotient," we note that while Dietrich covered most of her skin, the Princess of Wales appears to be displaying as much skin as possible, shoulders, neck, probably cleavage (although we cannot see it here), and leg to mid-thigh. But does this skin-show make the princess more seductive than Dietrich?

It is all in the eye of the beholder, of course—and possibly in the *age* of the beholder. For here Princess Di represents a modern style of sexiness—an unsubtle, "out there," extraordinarily robust sexiness, while the painfully thin, almost tubercular-looking Dietrich represented the sexiness of a generation that still was turned on by feminine weakness.

Like Dietrich, Marilyn Monroe was the sexual icon of her generation. And in a way, Monroe's seductiveness can be seen as an intermediary step between Dietrich's and Princess Di's.

........................

Oh, those fleshy lips, that open mouth: only a heterosexual male made of steel could keep from fantasizing about how he would like to make contact with that open mouth. The rest of Monroe's face looks placid, doll-like—an implicit message of *"Play with me."* She looks directly into the camera with practiced "bedroom" eyes. And the exposed tops of her breasts and bare legs are also invitations to sensual touch. She, like Princess Di, is voluptuous, but there is nothing athletic about her appearance—it is all yielding softness. There is a great deal of seductive power in that softness.

Her dinner companion is the British film actor, Laurence Olivier, with whom she was rumored to have had an affair during their filming of *The Prince and The Showgirl*. Olivier is clearly a peripheral figure to the sexy center of attention, but it is amusing to see his appraising stare at her legs captured here. He simply cannot help himself.

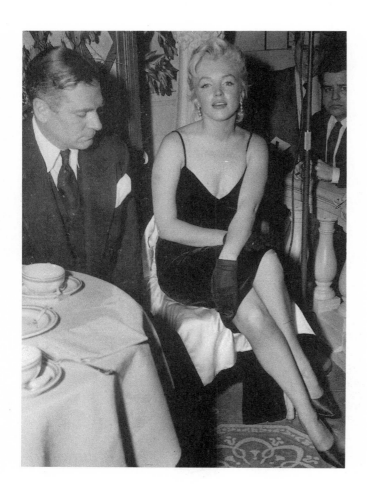

I hope the reader will forgive me, but I cannot help *myself* from following the previous photograph with this one. At center is another long-legged "beauty" who was the alleged object of Laurence Olivier's sexual attention, here performing with Jack Benny, Jack Carson, Van Johnson, and an unidentified performer at a Friar's Club gala.

........................

Yes, folks, it is the actor and comedian Danny Kaye in drag. He portrays a prima donna with comic *hauteur,* yet the real deception is hidden: Kaye allegedly carried on a homosexual affair with Olivier for over ten years. By humorously *playing* a woman, he throws off any suspicions the viewer might have about his true sexuality.

Is Kaye seductive in this shot? Again, it's all in the eye of the beholder. And if that beholder is Laurence Olivier, we may be curious to look back at the photograph of Marilyn Monroe for clues to Sir Laurence's collective taste in men *and* women.

What is going on in this photograph taken in Bombay, India?
Laundresses taking a break from work?
High schoolers taking a break from classes?
Whatever is going on, it appears to be a rather joyless enterprise.

......................

The joyless enterprise depicted here is waiting for "Johns"; the girls are whores who are waiting for customers. Even allowing for culture differences, we are struck by the relative lack of seductiveness evident on their faces and in their body language. Is this lack of seductiveness because they look so young? So poor? So unclean? Or is it mainly because they look so joyless, as if, sure, they'll do "it," but only under duress. (The "whore" of the Freudian fantasy alluded to above is a willing partner, not a loath one.) This looks like a grim business—the *job* of sex, not the *joy* of sex. And perhaps that is all this business ever really is.

If the previous photograph is an image of the pathos of commercial sex, this one might be called, "The unsexiness of commercial pathos." It is a photo of the well-known incident at the 1994 Olympics when U.S. skater Tonya Harding pleaded with the judges for their indulgence because one of her skate laces had broken. At the time of this incident, we did not know for certain that Ms. Harding was at least partly responsible for the savage battering of rival Nancy Kerrigan's knee. But looking at the photograph now, when we know this to be a fact, it gives the image its overriding subtext.

....................

Abbreviated costumes that expose the leg all the way to the crotch are de rigueur in figure skating, so Tonya can expect little seductive power by showing it all here. No, she is trying to seduce with the pathetic look on her face. Near tears, she seems to be saying, *Poor me! All those false accusations and now this!"*

The judges bought Tonya's story, but clearly the woman next to them, wearing headphones, is skeptical, to say the least. For us, now knowing just how far Ms. Harding was willing to go in order to bring home a medal, the whole scene looks fraudulent—and hence not seductive in the least.

In this next pair of photographs, the joke is on me. The occasion is my sixtieth birthday party and my daughters had arranged surprise entertainment. When the entertainer arrived at the door, I was certainly surprised—I immediately assumed that the sexy blond woman in colorful clothing was a stripper. I was flushed with shock and, I admit, excitement. But the blond in question turned out to be the "hat lady," an artisan who quickly fashions party hats to fit her impression of each guest. Later, when I confessed to my family that I first had thought she was a stripper, I was roundly teased. But looking at these photographs now, I wonder. . . .

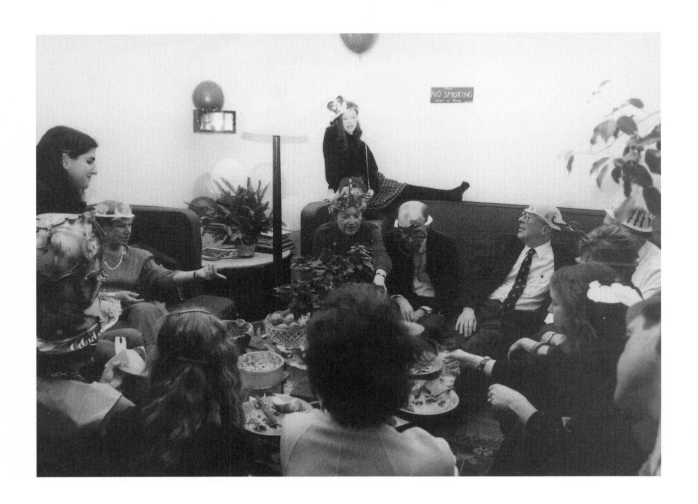

The first photo captures the good old-fashioned family fun befitting the occasion. But the second, of the "hat lady" in full regalia and at full steam, shows that my initial assumption was not so far off: there is clearly something broadly sexual about the woman—her scarlet eye shadow has more than a hint of the "scarlet" woman and that open mouth with its extended moist lower lip is about as seductive as it gets. Let's face it: the "hat lady" did seduce me—at least visually.

I would be remiss (and guilty of sexism) if I did not include an image of male seductiveness. No public personality better represented this than the "King," Elvis Presley. Here he is seen working the crowd of early morning fans at his arrival home in Tennessee after his two years abroad in the Army.

...................

The press made much of Presley's flagrant sexuality, dubbing him "The Pelvis" for what was then considered lewd bumps and grinds of his midsection while performing. But this was only one half of his fabled seductiveness; the other half is captured here. His handsome face has an unthreatening softness about it and his smile a genuine shyness and gratefulness for his fans' devotion. He greets all these adoring women warmly, personally—not with an idol's reluctance or disdain. In all of this he projects an image of being "just folks"—he is a polite and personable young man you could bring home to mother. Thus, Elvis tantalizingly combines opposites: hormones with hominess.

To conclude this section on images of sexual seduction, I offer this candid photograph taken on Spain's Costa Brava by my friend, the photographer Padraic Spence.

........................

This must be the very essence of sexual seduction: a nearly nude, voluptuous young woman lying on the sand next to a bare-chested young man. Talk about coursing hormones!

Yet when we examine each individually, we note that the nearly nude young woman has her eyes closed and appears totally inside her self, oblivious to everything but the sun's rays. Likewise, her partner seems barely aware of her sensual proximity to him. In fact (and this is the photographer's little joke), when we closely examine the magazine he is reading, we see that that the headline and photo are *sexually titillating*. In short, what we see here is the sexually seductive power of a two-dimensional image triumphing over the sexually seductive power of the flesh!

The First Seduction

From the point of view of psychoanalysis, everyone's first experience of seduction came from a parent, usually one's mother. Like Original Sin, this Original Seduction has implications that follow us for the rest of our lives.

Once again, still photography has an amazing capacity for capturing something essential about the seductive power that a parent consciously or unconsciously exerts on her child. I find the most telling images of this in mothers with older children, at the time when the child is usually in the process of trying to separate emotionally from that parent.

Here is a photograph of the actress Jodie Foster attending a show with her mother—at this point a single mother who served as her daughter's "manager and best friend."

Jodie looks confident, happy, and very secure—in short, she looks like an adored child. And we do not need to look far to see the source of her adoration: Mom looks about as proud and loving as it gets.

All in all, to me it looks like a healthy situation: no hidden strings of maternal seduction to hold back the young woman's growth.

But what if we were to add the context that the mother was at this point living in a lesbian relationship and we were to note that Jodie was wearing a suitcoat and tie? Would that make us think that there is something unhealthy going on here? Not me. I trust the unvarnished love in their faces.

And here is a photo album snapshot of a teenage boy and *his* adoring mother—a picture that tells a quite different story.

........................

Like Mrs. Foster, this adoring mother gazes affectionately at her teenager, but unlike Mrs. Foster, this mother is trying to make physical contact with him, to embrace his shoulders. And her son, unlike Jodie, is apparently not at all happy with her adoration or the attempted embrace. He looks reluctant to be there, to say the least. Note the sour expression on his face and the way he leans away from Mother, hanging onto the car as if his life depended on it. In this context, the mother's embrace looks like an attempted restraint of his freedom.

The teenager in this photograph is now an older man, but when I showed it to him he instantly recalled the context in which it was taken: *"I was home from school on vacation. I just wanted to drive around and see my girlfriend. I remember thinking, 'God, get me out of here!' I didn't want my picture taken, especially with Mother. She was looking at me so expectantly, as if she wanted something from me. God knows what."*

God knows what, indeed! Go, young man! Get out of there!

The Power of Seduction of the Powerful

During the period when he was dating glamorous starlets, the far-less-than-handsome former secretary of state Henry Kissinger was asked the secret of his attractiveness to these women. "*Power* is sexy," was his famous reply.

Long before Clinton exercised this power with a young intern, other presidents have enjoyed the aphrodisiac power of their office. Take a look at this group photograph of President Franklin Roosevelt and members of his extended family. For reasons of vanity, Roosevelt never allowed himself to be photographed in his habitual wheelchair, so here he is seen bracing himself upright with the help of a cane in one hand and his son Elliot's arm in the other. But it appears that the president's vanity also revealed something else in this photograph. (Remember, Roosevelt was later revealed to have had his share of extramarital affairs.)

...............

The official wire service headline was, "Four Generations of Roosevelts," but it could well have been, "An Eye for the Ladies." We are immediately struck by the look FDR directs toward the pretty woman on the right and by the shy-yet-adoring smile she beams back at him. The young woman in question is the wife of his son James— in other words, the president's daughter-in-law. No matter, she is simply the only truly pretty woman in the entire group and the president's look seems to reflect that fact.

What makes the photograph amusing are the expressions on the faces of the two other main women in FDR's life. The woman next to the pretty daughter-in-law is the president's mother, and she certainly seems to be looking daggers at the smiling young woman. (Perhaps the senior Mrs. Roosevelt merely felt that the eye contact between the president and his daughter-in-law was inappropriate for this family photo-op; on the other hand, maybe the president's mother knew a thing or two about her famous son's proclivities and wanted to put a quick stop to whatever might be starting here.)

Then there is the president's wife, Eleanor, in the lefthand side of the photograph. Never known for her physical beauty, she looks particularly homely here as she gazes glumly into the camera. We are struck by the way Eleanor and the three family members immediately around her seem to comprise a totally separate and saturnine group, while the half-turned president and the half-turned pretty young daughter-in-law frame a separate and lively group.

This photograph of President Clinton with Yasir Arafat is probably not the one of Clinton that you would expect to find in a section called, "The Power of Seduction of the Powerful," but I chose it for a couple of reasons that will become evident below.

It is pretty obvious who is trying to seduce whom in this picture. Arafat is pulling out all the stops with his two-fisted handshake and his smarmy, over-the-top smile. Note how he has edged over in his chair to be as close to Clinton as the furniture will permit. Clinton, on the other hand, appears somewhat withdrawn, the reluctant maiden amused by the eager suitor's importunements. Yes, it all comes down to the timeless calculus of who needs whom more—and Arafat needs Clinton's help and money far more than Clinton needs his.

But there may be an unusual and somewhat unsavory context to this photograph that was revealed much later and that gives Clinton's rather dazed expression added meaning. Arafat had been kept waiting for this photo-op while Clinton took care of some important business in his private office—that business could have been a sexual encounter with his intern.

The outcome of the O. J. Simpson criminal trial, considered a travesty of justice by many people, was determined by issues other than merely law and evidence. Race was crucial (the jury was preponderantly African-American), but so was the power of the defendant's personality. Simpson is a celebrity of both sport and entertainment. He is also (and this is one of the keys to his celebrity) a remarkably handsome and powerful-looking man with a charismatic personality.

Here is a photograph of the infamous trial ploy when Simpson tried on the gloves he supposedly wore during the crime—and struggles mightily to get them on. (His masterful attorney, Johnnie Cochran, gave the jury the rap-like instruction, "If the glove don't fit, you must acquit!")

....................

In this photograph we are meant to believe that the powerful, Heisman Trophy–winning halfback is grimacing from the exertion and discomfort of trying to pull on a glove that does not fit. *Give me a break!* How could it possibly fit over the protective glove he's already wearing? Would the glass slipper have fit Cinderella if she'd been wearing socks? But what is most telling to me about Simpson's expression is the asymmetrical curl of his lips—it looks for all the world like a *sneer.*

Was this expression of *arrogance* a mistake on Simpson's part? Or did it only add to the powerful seduction of his personality by saying, *"Hey folks, I am beyond all this silly business."*

Judging by the trial's outcome, it was not a mistake at all.

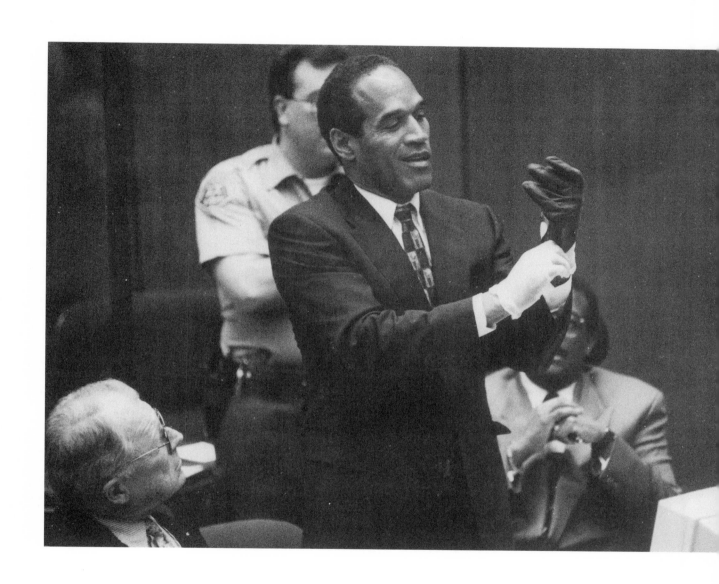

Here is a double portrait of two immensely powerful personalities in the world of classical music, the legendary French composition teacher Nadia Boulanger and the world-class composer and conductor Leonard Bernstein. The occasion is the presentation of the Medal of the Legion of Honor from Boulanger to Bernstein in the aged woman's Paris apartment.

......................

What could bring the powerful and notoriously egotistical maestro Leonard Bernstein to his knees?

Is he humbled by being in the presence of the woman who tutored such great American composers as Aaron Copland and Virgil Thomson? Perhaps. Copland was Bernstein's greatest compositional influence.

Or is what we are seeing simply a man kneeling so that he can receive his medal from its chair-ridden bestower? In fact, the two are good friends, and he is showing his love and respect as he listens to her every word.

Here is another extremely powerful man, the multibillionaire J. Paul Getty, in this scene holding a sparkler for the amusement of his guests, fifty-two orphans who have come to the rich man's house to celebrate Christmas. For Getty, it was a double-celebration: his grandson had just been released by kidnappers.

············

Who is seducing whom in this picture?

The billionaire in the middle owns all the toys, while his guests, at the other end of the economic spectrum, can only expect crumbs "from the rich man's table." But the billionaire in the middle appears more pained than powerful, more meditative than exuding confidence, while his guests look happy, plain and simple. The guests have something on their side that no amount of money can buy: youth and the exuberance that comes with it.

There is something touching about the contrast between Getty's elegant attire and his silly, clown-like party hat: he is trying to entertain the kids, to bring himself down to their level, but it is an awkward attempt. One wonders what is going on in his mind: perhaps that no one would kidnap any of *these* children—there would be no one to pay the ransom. Yes, there are burdens in being fabulously rich and powerful that these children will never have to endure.

But as to who's the seducer? I put my money on the sparkler itself. It seduces the children with its brightness and shimmer. And perhaps it seduces the meditative billionaire with its ephemeralness.

The Seductive Power of "Innocent" Charm

"Weakness is power," a wry philosopher once said. Indeed, where arrogance fails, innocence and obsequiousness often succeed. The message is, "I am no threat to you, so you risk nothing by giving me what I want."

Often, the projection of innocence is genuine, but often, too, it is feigned or posed. And still photographs are remarkable in their capacity for revealing instances of this latter category.

Here we see a Chinese worker attempting to persuade a policeman to join the prodemocracy demonstration during the Tiananmen Square riots.

........................

Standing directly in front of a uniformed policeman, the worker presses his hands together in a prayer-like, pleading gesture, and offers his version of a charming, eager-to-please smile. He doesn't have the gun, so the seduction of charm is his only weapon.

Do we detect something insincere on the worker's face? A hint of mockery in his smile? Or is what we are seeing a culturally-shaped facial gesture—face-language for obsequiousness? And then we might ask, does the smile's gestural formality make it any less sincere?

In any event, it seems to be having some effect on the policeman: we see the hint of a smile tugging at his lips as he looks back into the worker's eyes. (Of course, it is extremely doubtful that the encounter caused the policeman to throw off his uniform and join the protest.) Note the critical eye that the policeman next to the one in question is casting at him: it seems like a warning not to let his response go any further than that little smile. Also note the look on the face of the young man to the worker's left: he seems impressed with his comrade's daring. And finally, note the disembodied "V" peace sign in the background: a gestural symbol that has moved from Churchill's World War II victory sign to American war protestors of the '60's peace sign to China's prodemocracy demonstrators in the late '80s.

Here is another face that seems to embody pure innocence: a grown man singing along with a hall full of schoolchildren in Wales. Take a guess at what his relationship to these children is:

Is he a simpleton who is still in school along with fellow students who are a fraction of his age?

The guest soloist from the Royal Opera Society?

The choirmaster demonstrating how to sing properly?

Actually, it's the local truant officer. And if the attached news copy is to be believed, he is simply a man who loves to sing and is much beloved by all the schoolchildren.

........................

Oh, those innocent choir-boy eyes, the earnestness on the man's face, his goody-two-shoes erect posture as he holds the song book directly in front of him. Is it all too good to be true, especially when we know that he is the truant officer—the man who tracks down children missing from school without an excuse?

Looking at the children's faces for a clue, I am struck by the expression on the little girl directly in front of the man. She looks timid on the brink of being frightened. Is it only the camera that frightens her? Or is she reflexively afraid of the truant officer, perhaps based on personal experience? We'll never know. But at least it makes me wonder how this photo would have looked if known truants had been placed all around the "beloved" man.

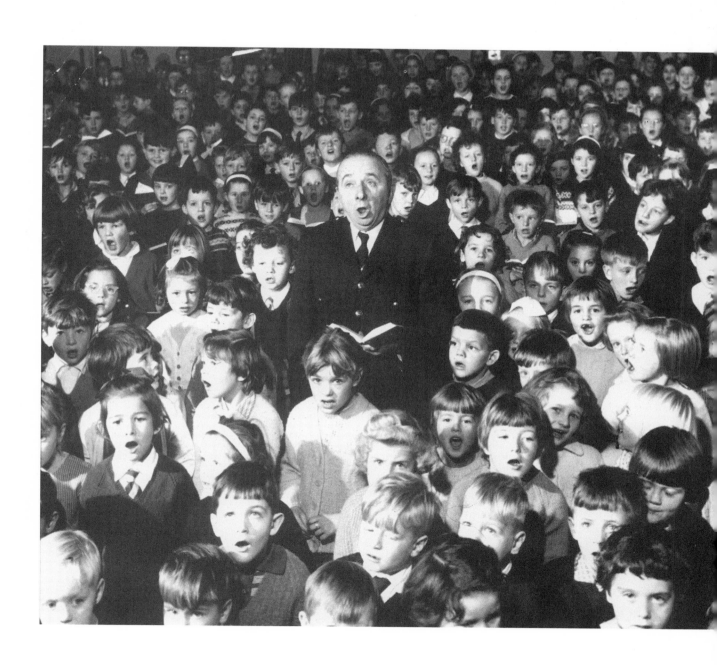

The next two photographs are from the popular public relations genre that puts out the message, *"Aw shucks, we're just ordinary folk like you."* It is a form of (usually) feigned obsequiousness that lets fans feel as if the stars do not think they are special or elite; rather, they lead ordinary lives with the same ordinary pleasures as their fans have.

Shirley MacLaine made a career of portraying the naive (and often exploited) girl with a heart of gold. Thus, a "just folks" image fanned the flames of her stardom. Here, Ms. MacLaine is in London, following the opening of her film *The Apartment* at Cannes. She is twenty-six and at the time the most sought-after actress in the English-speaking world.

...................

Indeed, Ms. MacLaine does look genuinely happy and at ease with this bench full of "civilians." Yet, surely she is conscious of the camera's presence (the woman on the far left certainly is) and of the purpose of the publicity shot. So, we might ask, what else is she conveying to us besides being "just folks"?

It's all in the legs. Granted, she has no competition from the other two pair of female legs pictured here, but Shirley is displaying her finely turned dancer's legs for all they are worth (plenty). And in that display, she does not exactly "blend in" with the common folk, does she?

Here is the famous French boulevardier Maurice Chevalier, also demonstrating his "common touch" with a pair of London youngsters. This publicist has also chosen a park bench for the setting—nothing is quite so democratic as a park bench. And it hardly seems coincidence that Chevalier's charmed new "friends" are little girls: his song "Thank Heaven for Little Girls," from *Gigi*, was a current hit.

......................

Like Ms. MacLaine, Chevalier demonstrates a seemingly genuine ease and warmth with the two girls, especially with the animated one on his left who brings a smile to his face. No, nothing fake about this imagery.

But again, it is the reason for the imagery that makes skepticism creep into the viewer's eye. This is, for all, a consciously designed publicity shot that is meant to seduce the viewer into thinking that Chevalier is all warmth and kindness. Yet at the time of this photograph (1961), it was becoming known that Chevalier had been a Nazi collaborator during the occupation of France.

Lest anyone think that this writer is terminally cynical, here is a photograph of a grown man at the height of his formidable political power being charmed by a small boy. Then-governor Mario Cuomo, was dedicating some public land on Lake Champlain when a little local boy (with his cousin) presented the Governor with a bouquet of wildflowers picked from the open land.

.......................

Although this is a public event (albeit in a rural area) and Cuomo is a supremely public man, I am struck by the way he is crouching to make contact with the boy and the genuine interest on the governor's face. He looks the boy in the eye with kind eyes; he says something to him (something about his cousin's Mets hat, it turned out); he appears in no hurry to move on to the next "photo-op."

And that is probably because this is not a "photo-op"—it is a candid moment in the life of a man who genuinely enjoys meeting the public.

The Seductive Power of Objects

In the photograph of J. Paul Getty and the orphans, we saw an example of the seductive power of an object—the sparkler in the billionaire's hand. With all the power that man had, it was the inanimate (though animated) object that riveted the attention both of the young people and of the elderly man himself.

Here is another photograph of a group of children being seduced by an object, in this case a wind-up gramophone (forerunner of the phonograph), which is playing a song. Upon seeing this photograph for the first time, without knowing its context, I automatically assumed that the period of the photograph was the early part of the twentieth century and that these children had never heard recorded music before.

In fact, this photo was taken well into the television age, but these children had never seen this ancient artifact before. Nor, for that matter, had they ever heard Frankie Laine sing "Mule Train" (the song playing) before. The local junk merchant had set it out for them.

........................

What we are beholding here is a bit of urban archeology. Clearly, these kids are fascinated by this object. Just look at their faces, especially that of the little girl right in front of the gadget with her finger to her mouth in a gesture of mystification. But why should these children be amazed? They have television sets and automatic record changers at home, so what is so wondrous and seductive about this gramophone? Just that it is old and unknown?

My guess is that this object fascinates because of its very rudimentariness. That mechanical simplicity (wind up by hand, place needle on by hand, sound emerging from an adjunct to the needle itself) enhances the utter remarkableness of an object producing the sound of a human voice. A sleek modern object with its mechanics obscured and its electronics beyond even a hint of common understanding is less fascinating because it all just seems "magical" as compared to "ingenious."

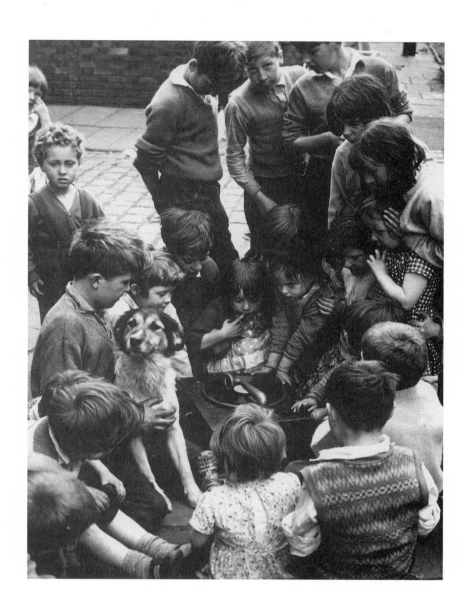

It is only natural that our consciousness of the seductive power of objects would lead us to employ objects to call attention to ourselves and to our ideas. In this famous photograph of the opera star Marion Anderson, the seductive object in question is the Lincoln Memorial in Washington. After Ms. Anderson was denied the venue of Constitution Hall by the Daughters of the American Revolution, presumably because she was black, First Lady Eleanor Roosevelt arranged for the free concert to be performed here.

........................

The symbolism of the Lincoln Memorial is perfect for the occasion—the Great Emancipator sits nobly behind a noble black artist as she sings. Her grandeur is echoed by his. He is an icon of black liberation bestowing a silent benediction on a black heroine.

Surely, both Ms. Anderson and Mrs. Roosevelt were conscious of the powerful symbolism of the Lincoln statue when they chose it as an alternative to the DAR's "sacred precincts."

Here we see another famous entertainer, Josephine Baker, attempting to use objects (and people) to dramatize her message. In this photograph, the singer, now sixty-one, has dedicated herself to building what she calls "Brotherhood Village," a home for a total of twelve children whom she has adopted from all over the world. The home itself is a chateau in the Dordogne, France, and the occasion for this publicity shot was Ms. Baker's effort to raise money to keep Brotherhood Village from failing financially.

If Ms. Baker's cause and her dream were not so noble, one would likely find the hokeyness of this photograph laughable.

Ms. Baker, once the sultry and glamorous star of the Folies in Paris, holds a metal bucket and wears a robe and housemaid's cap, giving her the air of a plantation worker (or even slave) from the old American South. Her pose exudes pitifulness, while her adopted children, also in robes and bearing buckets (apparently to gather water), dramatize their sorry plight.

But hold on. Yes, Ms. Baker's pose and her rainbow bucket brigade work on our sympathies—especially with its implied subtext that they are gathering water because they cannot afford running water. But what about that other object we see in this photograph—a wall and portal of the chateau itself. Note the fine stonework of that portal, the decorative relief sculpture just to the side and above Ms. Baker. Also note the stonework of the wall and the elegant roses growing up its sides. No ordinary orphanage this. In fact, by most standards, the whole setup looks rather posh indeed. And no number of buckets and robes and sorrowful sad expressions can completely counter the opulence suggested by the chateau itself.

In the remarkable documentary *Consuming Hunger*, filmmakers Freke Vuijst and Elan Ziff showed how it required images of starving families closely huddled on the desert to finally make the Western World respond to a two-year-old famine in Ethiopia. The fact that hundreds of families were visible on the same stretch of desert gave the image a Biblical appearance, evoking a sense of famine that the print accounts had never captured. Thus, even in real and important events, image is everything.

Ms. Baker would have done better to design her image of penury more carefully—too much sumptuousness in that stonework. Likewise, this photograph of Sarajevo residents waiting in line with plastic buckets to collect water after the bombed Bosnian capital had been without running water for months fails to capture our rather jaded sympathies.

..................

The people in this bucket brigade wait so patiently, in such an orderly and civilized manner, that the tragedy of the situation does not shout at us. Rather than ennobling these people, the fact that they have accustomed themselves to their privation makes them appear more ordinary—more like ourselves. And that works against our pitying them.

The prime objects we see in this photograph—the plastic buckets and the people's clothing—also work against a pitying response. There is no seductive power to these objects. The buckets look like the ones we use in our own kitchens—nothing primitive or quaintly impoverished here. And their clothing is virtually identical to the middle-class sports clothes we would wear to go, say, to the market or to the movies. I am particularly struck by the lovely print dress of the attractive middle-aged woman in the foreground—she looks far too middle-class to warrant our pity or charity. *But it is important to remember that that does not mean she does not need or deserve it.*

The Seductive Power of Animals

The power of animals to charm and seduce us is well known. We see endless photographs of cute kittens popping out of sewing baskets or sunning themselves on windowsills in greeting cards, advertisements, and on calendars. Similarly, idealized and, often, anthropomorphized drawings of animals are staples of cartoons and children's books.

Still, when we see an unposed shot of an animal caught in the act of charming a human being, we cannot help but be charmed ourselves. Here is one of my all-time favorites of this genre: Sir Winston Churchill being charmed by a Barbary Ape on the Rock of Gibraltar.

⋯⋯⋯⋯⋯

Sir Winston's own charm was legendary, but the rapt attention he gives this wild primate speaks for itself. Churchill leans forward, eyes fastened on the object that the animal is holding (a peanut), a tender and indulgent smile on his famous face. It is said that Russian leader Joseph Stalin never charmed Sir Winston for a moment. Clearly, this ape is succeeding where Stalin failed.

This next photograph—the last in this chapter on the power of seduction—played a pivotal role in one of the most dramatic and difficult psychotherapy cases that I was ever professionally involved with. (The case has become somewhat well known as a result of my book *Tales from a Traveling Couch.*) The patient was a circus worker who had been referred to me by the analyst Rollo May. Dr. May did not want to tell me anything about the patient's present problem, only that May considered it a "thorny case" that required an "unorthodox approach" and that he thought that I was the man for the job.

On his first visit, the patient (whom I call Charles Embree) began by telling me that he had a "work-related" problem. Only somewhat later in the session did he tell me the nature of that problem. (The following is an edited section from *Traveling Couch*):

"'I've fallen in love with someone at work,' he finally said miserably . . .

[W]hen Charles did not speak for several minutes, I prodded him with, 'And how is it going?'

'Up and down. Well, not very good, actually.' Charles wagged his large head back and forth. Then, with a sudden burst of passion, he said, 'I have never been so in love in my life, Doctor. Never!'

I looked at Charles sympathetically. For all the hundreds of times the broken heart of unrequited love has revealed itself to me in my office, it is always painful to behold.

'Tell me about ——' I stopped myself before I had to commit to a pronoun gender.

'She's an incredible beauty,' Charles jumped in ardently. 'Voluptuous. Intense. Provocative. I've wanted her desperately since the first time I saw her.'

'And she?'

'I have to win her over. It's all I really want in life,' Charles said breathlessly. 'And I think I can. It's just a matter of time.'

Charles was now fumbling with something in his shirt pocket. It was a photograph. He regarded it a moment with obvious fondness, then passed it to me. . . .

". . . I summoned up every ounce of self-control I had within me to smile calmly and say in a natural-sounding voice, 'She's lovely.'"

..............

Lovely, perhaps. But also lethal looking.

If ever the power of seduction was in the eye of the beholder, this must surely be it.

Humans, Objects, and Humans as Objects

I n the last chapter, we touched briefly on the seductive power of objects. In this chapter, let's expand on the theme of our relationship to objects as this relationship is captured in photographs.

One of the primary tenets of existential philosophy—and of the strain of psychotherapy based upon it—is that human beings are not objects, and that to treat ourselves as objects is both morally "unauthentic" and psychologically unhealthy. Human identity resides in the self and the chief expression of the self is the will, these philosophers and therapists maintain. Basically, I agree, but things get more complicated when we look into the ways we relate to objects—at times borrowing parts of identities from these objects.

Objects That Express Personal Identity

Uniforms are usually associated with a declaration of identity: "I am a policeman, soldier, etc. . . . and this uniform identifies my power and allegiance."

On the other hand, masks and costumes are usually associated with disguising our identity. Yet this is not always the case. In fact, a mask or costume is often used to represent that very part of one's identity that comes directly from the will: "This mask shows you what I really believe in and am personally committed to better than my unadorned face ever could."

Here is an example of this latter phenomenon: a contingent of

antiwar protestors marching down Fifth Avenue in New York City in 1965.

·····················

The image of skulls marching down the avenue to a dirge-like drum-beat is simple and powerful. *This is the outcome of war,* it says. *Death, death, death, and nothing but death.*

But this image also makes me curious as to what it feels like to be a wearer of this skull disguise, to impersonate the walking dead. I imagine that at least some of these men and women are so committed to their cause and so caught up in their "play acting" that they feel ghost-like. In the enclosed darkness of their skull-masks, they actually experience the emptiness of non-being.

The next image contains a more complicated story about the relationship of human beings and beliefs to symbolic objects. Take a guess at what is going on here:

A Nazi demonstration in prewar Germany? (No, the photo itself looks too sharp and clear to be of 1930s vintage.)

Neo-Nazis assaulting a young victim, one of their number approaching with an automatic weapon to finish him off? (Closer, but still not the whole story.)

No, these are young American neo-Nazis attacking an antiwar demonstrator in Washington, D.C., in the early 1970s. But it takes a close examination of this photograph to understand who the victim was and what he was doing that caused the neo-Nazis to single him out for abuse.

......................

First, let's take a second look at what appears to be an automatic weapon in the approaching figure's hand: it is not a weapon, but a broken stick with some kind of material flapping from it. A broken umbrella?

Now, let's look at the figures in the foreground wrestling in the street. There is a mysterious and ghostly hand reaching out from between their legs, but whose hand could it be? It is disembodied. Could it be a human hand that was broken off in the tussle? That seems extremely unlikely.

By putting these pieces together (along with the piece of black cloth being grabbed by the crouching neo-Nazi on the righthand side of the photo) we realize that stick, hand, and cloth were all part of a large-scale puppet that the antiwar demonstrator must have been parading in front of the neo-Nazis. The puppet was his symbolic object, just as their brown shirts and swastika armbands were theirs. What we are seeing, then, is a human battle over symbolic objects.

For a "chaser," let's look at the costumes and masks of a benign parade: the circus parade heralding the arrival of the circus in town. Are there any expressions of human identity and beliefs evident here? Or is it just mindless comedy?

.....................

Yes, it's pure comedy, but I don't believe it is mindless—comedy rarely is. The Keystone cop sits on a miniature motorcycle looking up at a clown whose outfit looks like the mismatched, found objects of a hobo scavenger—the very kind of person whom cops routinely hassle!

So what we are seeing enacted here is that classic gag, role reversal. The symbol of power (the cop) is literally in an inferior position to the symbol of powerlessness (the hobo-clown.) Rather thought-provoking for a mindless joke.

Objects That Express Wished Identities

There are, of course, times when we use objects to express an identity that comes not from the will but from the wish. Sometimes we do this seriously, half-hoping the disguise will somehow fool even ourselves. But most often we do it in jest—a joke at our own expense to take the sting out of the true situation. And sometimes, there may be elements of both at the same time.

Here is a picture of me with my wife on summer holiday.

....................

Okay, let me start with a confession: I am bald, have been for years—and I still don't like it. Visiting friends one summer, I came across a wild theatrical wig in my hosts' house and I couldn't resist trying it on.

The gag for others is obvious: *Bald Robi has suddenly spouted a full head of hair. Har, har.*

But the gag to myself is less obvious: *Beware of what you desire, Robi, for you may end up looking like a fool.*

In this photograph, two boys (cousins) have disguised themselves as girls, complete with lipstick and falsies. They paraded around in front of their parents and grandparents in these getups for some time and insisted on having their picture taken.

.....................

Should the parents and grandparents be concerned that they have a pair of budding transvestites on their hands? (Although, of course, many worse things could befall a child.)

As a psychoanalyst I am absolutely sure that would be a misplaced concern. On the contrary, what we are witnessing here is some very healthy play—look at the coy, ironic smiles on the pair's faces. They are playing with gender identity: *What would it feel like to be a girl? Gee, part of me thinks it's fun. And part of me realizes that it's not really so different from being a boy.*

I would be concerned if trying on these feminine objects caused the boys to "freak out."

Objects That Erase Personal Identity

One of the purposes of an official uniform is to subordinate personal identity to group identity: *I am not so much John Doe as I am a member of the Green Berets—and their will is my will.*

In a sense, this is exactly what the existentialists warn against: by relinquishing personal identity and will, we turn ourselves into objects.

But what if that uniform has nothing to do with power or political goals and everything to do with cultural identity? Is the self still turned into an object?

Here is a 1902 studio portrait of a young Swiss girl dressed in her family's guild costume in preparation for the annual "Sechselauten" parade.

.....................

The message (clearly her parents', not hers) is: *I am a member of this tribe, part of this tradition.*

We see the effort taken to make sure her elaborate costume looks just right for the camera. And we know that she's been told to sit perfectly still and not change her expression.

But the overall effect makes her look more like a doll than a human child, more object than budding self.

And here is an esoteric example of a similar phenomenon: an Iranian Dervish of the Gaudary sect piercing his body with a knife while in a trance state. Next day, there were no entry wounds or infections evident.

The act is so brutal, his face is so serene. We are witnessing something so incredibly foreign to the Western mind that we flinch in revulsion.

Yet if we deconstruct this man's act, it has much in common with the little Swiss girl's dressing up in a guild costume at the turn of the century: both involve the subordination of personal identity to a "larger" identity. Yet the Dervish appears to be taking this act a step further (or "higher"). He is employing a worldly object (the knife) to prove that with Allah's help he can transcend his "objectness," thus elevating himself to a higher realm. In a sense, he erases his corporal (object) identity to achieve a transcendent identity.

Humans Relating to Human-like Objects

In an era that has brought us animated holograms of human beings (a big hit at Disneyland) and the cyber "reality" of virtual sex, it is enlightening to look at photographs of humans relating to human-like objects in the recent past. Do we appear less human by contrast with these objects? Or more so?

Here is an arresting photograph I dug up from the archives. The time is the sixties; the place, the U.S.A. But what the heck is going on here?

The wire-service caption to this photograph identifies it as a run-through of radiation testing, presumably practice for the aftermath of a nuclear disaster.

...................

This posed tableau was probably meant to put the viewer at his ease with a message of *"Don't worry! We (the government) are prepared for every eventuality."* But that is hardly the effect it has on me.

My first reaction is to laugh: There is something comical about all these mannequins lying around helter-skelter (some, like the two male mannequins in the last row, identical to one another), while the real human in his radiation-proof getup "seriously" tests them for radiation. It really is hard to take the whole scene seriously.

But my second reaction is horror: *God! Maybe this is closer to what the aftermath of a nuclear disaster looks like than I thought! Maybe we, the victims, really would look like mannequins with frozen expressions on our lifeless faces!*

It's fun to pair the previous photograph with this one from about forty years earlier. Care to hazard a guess at what is going on here?

Right, it's a doll "hospital" and the doctor is in.

..................

What strikes me about this quaint photo is the expression on the little girl's face: all rapt attention and not a sign of alarm or horror.

When children play with the human-like objects called dolls, they usually attribute flesh-and-blood corporeality to them. The dolls are real people with real personalities, real wishes, and real affections. Why, then, does seeing a doll reduced to an object that can be fixed with a saw and spare parts not horrify the child by piercing this delusion?

I believe the answer is that children have the remarkable—and very useful—ability to inhabit two realities at once.

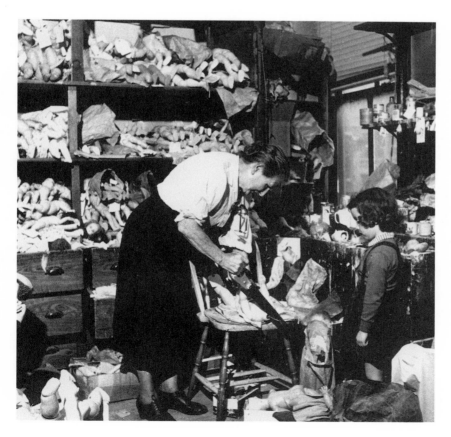

The next two photographs do not raise any existential questions that I know of, yet the contrast between artists' renderings of human beings with real flesh-and-blood humans does make us focus on the artists' intentions. It's obvious that the artists are not attempting to make human-like objects that are indistinguishable from real humans, so what are they up to?

Here is a famous statue of FDR and Sir Winston Churchill on a park bench on Bond Street in London.

......................

For starters, we see that the placement of the bronze figures is a photo-op waiting to happen. And it happens *very* frequently. So it is reasonable to think that at least one of the artist's intentions was to create this photo opportunity, to give families a chance to photograph their children between the great wartime leaders.

Of course, a real human between the monochromatic bronze ones only exaggerates the artificiality of the statues. But then again, that very artificiality underlines the timelessness of the real people the statues represent. The little child eating his sandwich will grow up and grow old, while FDR and Sir Winston are immortalized as well as immobilized.

The last photograph of this section is from my own photo album and I include it only for amusement's sake: no lessons here except that sometimes when you take a picture you do not realize what effect it will eventually have.

In this case, I simply wanted to record my wife, Ann, looking at a painting in the Louvre. Just a souvenir for the album.

....................

How can you help but love the way the figures in the gallery seem to tumble out of the crowd in the massive painting in the background? Are the visitors in the gallery an extension of the painting, or is the painting an extension of the gallery visitors? Fun.

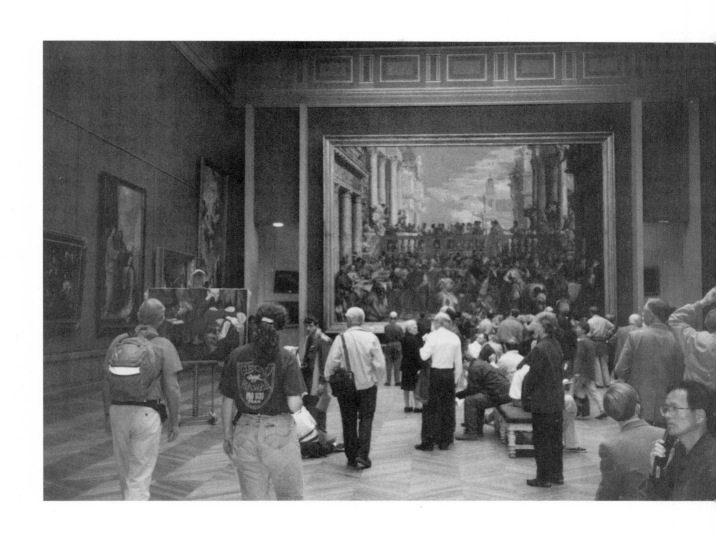

Objects as Human Emblems

Without depicting a particular human being, an object may nonetheless be emblematic of a person—or of an event in a person's life.

Viewing this photograph, nine out of ten people know exactly what it is, who it represents, and what it means.

Yes, it is the remains of the Mercedes that took Princess Di's life, along with that of her companion, Dodi Al Fayed.

.....................

It is just another car wreck, like others that we have all seen before. But in this case, we know who was in the car and what happened to her.

Princess Di had become part of our consciousnesses, like a family member, and when she died, many of us mourned her as if she were a family member. Thus, looking at this image, this inert, mangled object, we respond with feelings for a lost human being.

Chapter 7

Narcissism and Self-Involvement

It could easily be argued that most photography is a form of narcissism: the subject's narcissistic desire to preserve and see his own image, and the photographer's narcissistic desire to preserve and display his own personal vision of the world.

But beyond this blanket application of the concept, photography—especially candid photography—has a stunning capacity for capturing moments of narcissism and self-involvement in our daily lives. The camera's ever-watchful eye catches us turning inward.

No Pity

In the national debate about the causes of our moral decline, we often overlook the simplest and most telling signs of how our egoism is eclipsing our altruism. But in the deeply disturbing photograph that follows, it strikes us right in the eye.

This photograph needs no deep analysis. A homeless man sinks his head in despair while commuters catching their homeward-bound buses pass him by, totally ignoring him. The sleekness of the man in the trench coat, the jauntiness of his stride, heightens the sense of callousness we feel coming off him.

But consider the context of this photograph: it is a city (New York) in the 1990s, where homelessness is visible everywhere. (Not so just twenty years ago.) People suffer from "poverty fatigue"—a feeling of helplessness to change the situation followed by a feeling of annoyance at having to witness it every day of their lives. Does this make the image any less compelling? The evident callousness and egoism any less reprehensible?

Lest we think that this callousness is a new stain on the American character, consider this news photograph from 1935 of a lynching in Ft. Lauderdale, Florida. According to the news report, the black man was murdered because he "frightened" a white woman.

.....................

Our eyes are drawn immediately to the face of the little girl gazing up at the lynched man. She looks amused: *That's funny! A dead man hanging from a tree!* We don't sense an iota of pity or moral outrage in her open smiling face.

But again, consider the context: the American South in the 1930s, a group of adults around her who believe justice has been done. What will this little girl take with her into adulthood from this experience?

If she were to look at this photograph now, sixty-odd years later, would she feel any shame?

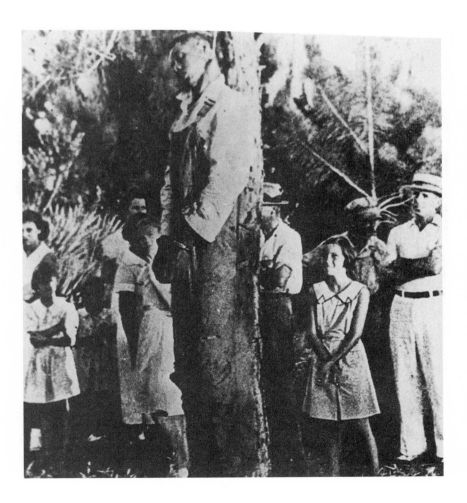

Flash forward to the '90s again. The scene is another murder, this time the government-approved execution of convicted murderer Robert Alton Harris at San Quentin Prison. The young men pictured here are pro–death-penalty activists in counterdemonstration to anti–death-penalty activists outside the prison on the night of the execution.

......................

Were it not for the pickets and the words on the T-shirt of one of the demonstrators, we might think we were viewing fans at a college football game. *Rah, rah! Go team, go!* This is more than the demure amusement of the little girl pictured above; these guys are partying hard because a man is about to be killed. Granted, the executee is a murderer himself and not an innocent black man who "frightened" a white woman, but does the apparent mirth these boys are express-ing have anything at all to do with the sober business of justice being done? Do these faces show any consciousness of what it means for a life—*any* life—to end?

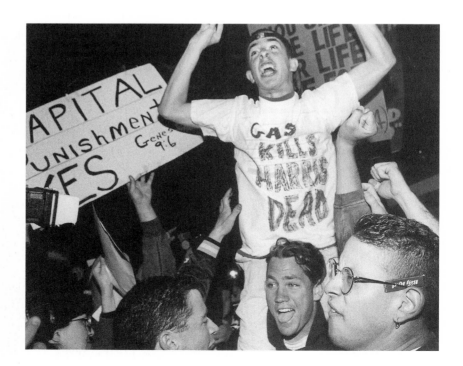

Finally, let us compare the previous photograph with this one. Same time, same place, but this is an anti–death-penalty activist who wants to place roses at San Quentin's gates out of respect for the dead.

........................

We are struck first by the contrast: the woman seems serene in comparison to the rowdy pro–death-penalty demonstrators.

But as I consider the context and look again at her face, questions are raised in my mind. Does this woman really believe her action will have an effect on public opinion? Yes, this is definitely a photo-op (note the TV cameras on the other side of her) and that is undoubtedly her plan: to send out the message that people really care about a murder victim, whoever it is. Yet, looking again at her face and the slight smile she is offering the policemen, do I detect some self-satisfiedness, a hint of moral superiority—itself a form of narcissism?

The Great Disconnect

You can gather people together, but you cannot make them connect with one another. And nothing highlights the quality of self-absorption so much as a group photograph in which some or all of that group are in a state of "disconnect."

Here is a photograph of the most celebrated American playwright of the twentieth century, Eugene O'Neill, with his wife and children at their home in Bermuda.

Our eyes are drawn immediately to the face of the playwright himself as he glares into the camera. It is not the face of a happy man. Everything about him appears ill at ease: the uncomfortable-looking position of his crossed legs, the stiffness of his posture, the overall awkwardness of his purchase on the bench. His left arm is folded back and does not appear to make contact with his wife; nor does the hand on his lap. In fact, everything about his pose sets him apart from his family—a total disconnect.

Mrs. O'Neill appears not only disconnected from the family group but hardly there at all! Her vacant stare and slightly open mouth make her look as if she is lost in another world, stunned into oblivion—nobody home. She seems less vital than the inert bronze statue of FDR and Churchill on the bench.

The children appear pleasantly preoccupied with their own little drama—the stuffed animal that has apparently slipped to the ground from the young girl (Oona)'s hand. They are clearly more emotionally connected to this object than to their parents.

In all, I find it a very sad photograph but, knowing O'Neill's opus, hardly a surprising one. O'Neill's classic, *Long Day's Journey into Night*, is the quintessential portrait of a dysfunctional, disconnected family.

Here is another celebrated family, the New York politician Rudolph Giuliani, being sworn in for his second term as mayor of New York City, as his wife, the television journalist Donna Hanover holds the Bible, with their daughter Caroline on one side of her, their son Andrew between them. Young Andrew made headlines at the first inaugural by clowning around so much that he upstaged his father. Unlike the O'Neill family photograph, this was taken at a public event.

The mayor looks earnest and proud, his eyes fixed on the only other official in the group, the judge (far right) who is presiding over the oath-giving. Giuliani, a former prosecutor and law-and-order administrator, is often accused of putting the rule of law over and above a sense of compassion; and here, indeed, he is putting his respect for the judge above any sense of connecting with his family.

The expression on Mrs. Giuliani's face reminds me somewhat of Mrs. O'Neill's above: she looks as if she is turned inward, pulling herself away from the here-and-now.

Young Andrew has clearly been prepped for the occasion: *No clowning this time, young man!* He holds his hands together as if in self-restraint, yet the mugsy hat he chose to wear and the smug expression on his face suggest that he is willfully going overboard with his "good behavior," perhaps mocking it. And I believe he may still be competing with his famous father with that expression on his face: *I'm a tough guy, too, and don't you forget it!*

Only young Caroline seems at ease in this family portrait. It looks as though she has caught the eye of a friend in the audience.

Finally, here is another wonderful candid photo by the photographer Padraic Spence. It is a bus queue in Lisbon, Portugal.

....................

Of course, all these people probably have in common is that they are waiting for the same bus. Nonetheless, one is struck by how separate each person is, how each seems silently inside him or herself. Looking from left to right, a man inspects a package; a woman inspects her nails; the next woman looks a bit exasperated by having to wait; the next man lights a cigarette while scanning passersby, perhaps for a good-looking woman; the next two women look as if they might be together, but have nothing to say to each other; the next man stands in the classic pose of self-containment, arms crossed in front of him; and the man at the head of the line reaches into his pocket for something—a bus schedule? Not one of them relates to another.

This photograph may tell us more about Portuguese culture than about these particular individuals. The photographer told me that Lisboans are notoriously reticent, that a picture of a bus queue in, say, Rome, would tell quite a different story—"endless noisy connections of one to the other."

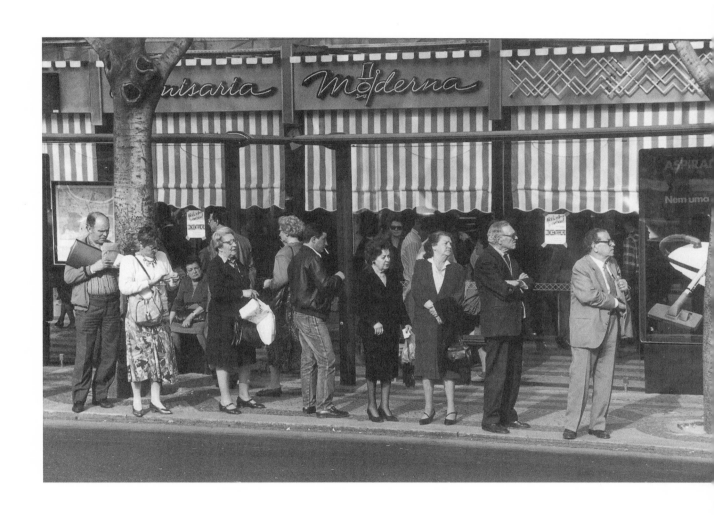

Chapter 8

Reality Checks

I want to close this book with what brought me to photoanalysis in the first place: Photographs as "reality checks" for memories of our personal histories.

For me, this began when I first asked a patient to bring his family albums to a therapy session to see if the photographs could help him remember periods of his life that he could not summon up from memory alone. The ensuing sessions were dramatic and surprising for both of us, for not only did the photographs stimulate his memory, but they also "corrected" certain memories, especially those memories that had been reinforced by family myths. With this patient and others, I found ever-expanding productive uses for family photographs, including those discussed in the section on time-lapse photographs ("Plus Ça Change") and the section "Public Displays of Pure Emotion." And later in my career, when I became interested in "elder wisdom" and the life stories that distill and convey this wisdom (see my book *Family Tales, Family Wisdom*), I again found family

photographs to be an uncommonly rich source. But in the end, it was this original impulse that proved most enduringly valuable: *to determine the reality of past experiences and help correct distortions of memory.*

By this, I don't simply mean the corroboration or disputation of straight facts, such as how old one was when the family vacationed at Niagara Falls or who exactly came to your First Communion. Rather, I see a close examination of photographs as a way to test the assumptions of old myths and what I call "the family version" of the way things were.

Let me begin here with a subtle piece of reality checking that took place in my office many years ago. A patient (whom I will call Sally) came to me because she was experiencing sudden, uncontrollable, and often violent outbursts directed against her husband and her friends.

When I tried to get to the root of her anger with standard psycho-analytic prodding, she kept insisting that she had been perfectly happy as a child, that she had been as content and placid as the day was long. When I asked her to bring in photographs that showed just how very happy she was, Sally produced this photograph.

························

Sally in her Communion dress looks, as she told me, "Like an angel without wings."

"Who took this picture?" I asked her.

"My father."

"He must have been very pleased with you," I said. "You look like the perfect child."

Sally nodded.

"I can't quite read the expression on your face, but you don't look particularly happy." I went on, "What do you suppose you were feeling at that moment?"

"Special," Sally replied reflexively. "I felt special."

"Anything else?"

Sally stared at the photograph, into her own eyes twenty-odd years earlier. For several moments, she said nothing. And then she blurted out, "I look kinda frightened, don't I?"

"Frightened?"

Another long silence, and then tears began to slip down Sally's face. "I was terrified that he could see what I was really feeling about him. I wasn't such a perfect angel, you know."

I could see that Sally was struggling with what she would say next.

"Sometimes I wished he would die," she suddenly burst out as she began to cry in earnest. Sally had just experienced a rare and dramatic bit of reality checking that marked the beginning of a successful course of psychotherapy.

Here is another bit of reality checking via a photograph that proved to be a turning point in another person's life. A distant cousin from Seattle was traveling through New York and stopped by for a visit. We started reminiscing about our families and our lives, and that led to an extraordinary story.

He had been haunted by a recurring dream in which he was responsible for someone's death. He knew he had never done such a thing, but what would cause such a dream?

He asked me if I had ever heard any family stories that would shed light on his dilemma. No, I hadn't, but my mother had recently died, and I had all her family albums. I suggested we take a look.

............

"Isn't that you in the toy car?" I asked.

"My God, I can't believe it! I've never seen this picture."

"You look happy sitting there in the car. It looks like you've out-grown it though."

My cousin kept staring at the photo. I could see he was getting upset.

"Yes, I'm way too big for the car. This must have been around the time we moved, and my mother said we couldn't take the car along. I remember giving the car to a younger friend. Later we found out he had been killed in the car by a delivery truck."

"So that made you responsible for his death?"

"That's what I must have thought. It was so upsetting, I must have pushed it way back in my mind. I can see now I didn't cause his death."

Viewing the picture enabled my cousin to see the link between his recurring dream and the incident that had inspired it.

And here is another example of a long-lost photo image that caused a friend of mine to do some serious rethinking about his past. The photo is of his uncle, a man whom the entire family spoke of as crazy, despite the fact that this uncle had a successful career and many friends.

........................

My friend said, "When I came across this picture of my uncle in a shoe box in my mother's attic, I laughed out loud. This debonair man serving tea to his two beret-wearing hounds. And I realized that my staid and humorless family mistook Uncle Fritz's wit and eccentricity for craziness. For me, it was a liberating discovery."

A friend of mine asked me to take a guess at what the dynamic was in this family portrait that he had discovered.

........................

I was struck first by the man and woman in white at center. They both appear to be gentle and warm people who are lovingly close to one another, while the two men (brothers?) at either end of the group seem to be deliberately separating themselves from the others, aloof and, especially in the case of the leftmost man, disapproving. Could the man in white be the favorite brother or son? I wondered.

My friend told me that I was on the right track, but that the real story was more complicated and dramatic than that: They are brothers and sisters gathered uneasily for a Sunday afternoon. But the occasion is the brother in white's weekend visit from a psychiatric hospital, a visit promoted by the sisters and disapproved of by the brothers. Indeed, the "crazy" brother always was the favorite of the sisters (and of his parents) and the two brothers never did get over that, even after the poor man lost his sanity. (Incidentally, the man who showed me the photo was the son of one of those disapproving brothers—and for him this photo proved just how unyielding his father had always been.)

And here is a photograph that my wife dug up for me during one of my "Why-did-I-ever-become-a-therapist?" funks. It is a candid shot of me as a young camp counselor consoling a homesick camper.

........................

This shot brings me back to a time when I was unsure of what I wanted to pursue as a career. Looking at it, I recall the entire story surrounding it: The boy wanted to return home after just a week in camp. Compounding his homesickness (and undoubtedly a result of it), the boy had wet his bed and was mercilessly teased by his bunk mates.

I remember racking my brains, thinking up reasons why he should stay, but everything I suggested he rejected. Then I had an inspiration: "How would you like to have my job for a day—you be me and I'll be you?" That idea really got his attention; in fact, he jumped at the chance. And he astonished us all by how fair he was as the cabin counselor and how resourceful. I nicknamed him "Genius" and the name stuck for the rest of the summer.

As for me, I realized that wherever that inspiration came from, it might serve me well if I pursued a career in therapy.

Trusting Your Eyes

There is an old joke about a man who comes home to find his wife naked in bed and two drinks on the bed table. Searching around for the man who had been with her, the man opens the closet door and sees his best friend standing naked inside. Before the husband can say anything, his best friend says, "Don't jump to conclusions. Who do you trust—me or your eyes?"

It is a good question for any photoanalyst. Do you trust what you see in the photograph? Or the story that accompanies the photograph?

Yet often, when story and image appear to contradict each other, a deeper truth emerges—a truth that not only resolves the apparent contradiction but also synthesizes the opposing ideas. Consider this photograph of a two-year-old's birthday party (the boy in his mother's arms). The folks gathered for the party and the photo are the boy's extended family.

......................

My first thought upon seeing this photograph was "Lucky boy. He has a close, coherent, and loving family."

In fact, it crossed my mind that this photograph of four generations was a veritable poster for that overused political slogan, "Family Values." Virtually every face shines with warmth and lovingness. There is more eye contact and touching going on in this large family group than in nine out of ten family photos I come across.

But (and I learned this after my first look), this is a photograph of a rather atypical family group. The birthday boy has four parents: his biological mother (holding him) and her lover (the seated woman holding the boy's hand); his biological/sperm-donor father (man in glasses behind the boy) and that man's lover (the man in the checked shirt next to him.) The rest of the family are assorted brothers and sisters of these four (and some of their children), plus the grandparents and great-grandmother of the birthday boy.

In other words, this surely is not an image of what the politicos

who champion "Family Values" had in mind. But does that mean there is a contradiction between image and story? I don't think so. The loving extended family I first saw is the loving extended family I still see.

High school and college reunions are usually well-photographed events; they are also occasions for loads of stories. Here is my fiftieth reunion photo from my all-boys prep school. There are as many stories here as there are people, but surely one in particular screams out to be told.

<div align="center">............</div>

Okay, who the heck is that woman front row and left?

It's our classmate, Gloria, who was George when our classmate. Gloria's story, which she told me in detail, is typical of transsexuals of my generation: she tried to be a man, married, fathered children, the works. But finally, when she realized that "sex realignment surgery" was a genuine possibility, she did what she had always dreamed of doing: inhabiting a woman's body.

Of course, what is most striking about this photograph is Gloria's decision to make an appearance at our reunion. Remember, there is nothing quite so conservative as a New England prep school, yet there Gloria is in all her glory—smiling, assured, unashamed. Perhaps the classmate to her left feels a bit uncomfortable, but he appears to be smiling through it.

Psychoanalytic postscript: As an analyst, I cannot help but note the contrast between the way the men in the front row hold their reunion canes and the way Gloria does. The men hold it between their legs, instinctively phallic, while Gloria holds her staff to the side.

Mistakes Will Be Made

Twenty-six years ago, when I wrote my first book about photo-analysis, I had less tolerance for ambiguity than I do now. In truth, I probably saw the whole enterprise of photoanalysis as more of a science and less of an art than I do now. (One's tolerance for ambiguity seems to increase with age.) In any event, mistakes were made and I include one real whopper of a mistake here as a parting reminder that, no, we cannot always trust our eyes or our interpretations of images, no matter how convincing they appear to be.

Here is the photo in question, the crew of the *Pueblo* that had been captured by the North Koreans in 1968.

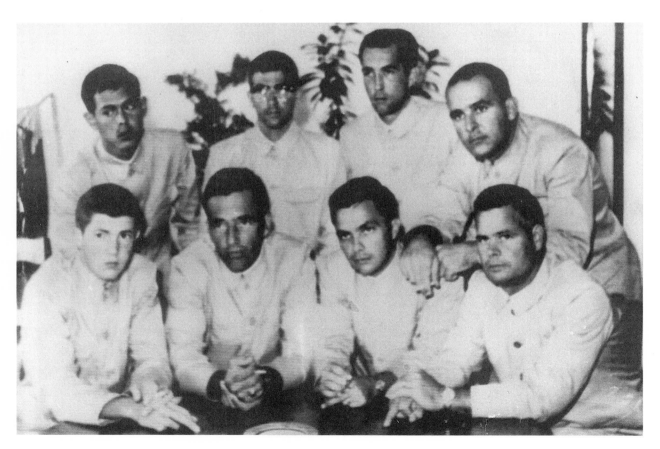

And here is what I wrote about them in that first book:

"Look at their hands, especially the fingers of the sitting men. Do you see a nonverbal message?

"Three of the men are giving the vulgar 'up yours' finger sign with varying degrees of commitment and openness—from the bold, extreme expression of the man on the extreme right to the more disguised, hesitant gesture of the man on the extreme left. The degree of commitment to their act also matches their facial expressions."

After that book was published, I received a letter from a relative of one of these men who corrected me: "In fact, these men's hands and fingers are using sign language to spell out—left to right—H.E.L.P."

My ignorance of sign language coupled with a projection of my feelings toward the North Korean captors was responsible for this critical mistake. Consider it corrected now. And remember, as I always must, that a "perfect" analysis of a photograph requires "perfect" knowledge—and thus is never completely possible.

Photographic Superegos

Let me conclude this book with another a little joke on myself—a joke about the limits of "Reality Checks."

Not long ago I was seeing a patient, oddly enough a photo editor for a magazine, who was constantly unhappy about how her family had turned out. Though there was nothing tragic in her family—no illness, physical or mental; everyone reasonably energetic and productive; everyone speaking to one another—she still thought her family fell far short of "what a good family ought to be."

I kept pressing this woman for what she expected of family life and one day she brought in this still from the Frank Capra classic, *It's a Wonderful Life.*

"*This* is what I long for," she told me.

........................

The photo, like the film, is a classic of idealized American life: George Bailey surrounded by wife and kids, all entwined in a loving knot—adoring eyes all around, the simple happiness of fulfilled love. Who wouldn't want to be part of this scene, this family?

"But," I told my patient, "It's a Hollywood ideal, not reality. And trying to live up to this impossible reality is one of the sources of your unhappiness."

In short, I was saying that her ego ideal (superego) was interfering with her enjoyment of her actual life. But I could see that she was unmoved by my argument.

Then I had an inspiration: I challenged the woman to find a photograph of a *real* family that was anywhere near as perfect an image of family happiness as this one.

That was my mistake. Here is the photograph she brought in the following week.

....................

Yes, it's the star of *It's a Wonderful Life* and his *real* family. And, by George, they look as happily entwined, as adoring-eyed and simply happy as the family in the film.

Granted, this is a publicity shot, but for the life of me, I cannot detect anything faked or fraudulent in it: from the happy smiles on the children's faces, to the loving look Stewart's wife is giving him, to Stewart's own closed-eyed look of utter contentment.

In short, Oooops! I needed to find another way to work with this woman's relentlessly uncompromising superego.

So I asked her how these photos differed from the photos in *her* family album. Without missing a beat, she replied, "That's easy. We all just stand there, looking at the camera. There's no holding or touching; we're not physical. And that reflects the way we relate as a family. I don't know why that is. But that's what I'm looking for— that sense of closeness."

And that led us to a whole new avenue of exploration.

Chapter 9

Your Turn

If my personal interpretations of photolanguage have convinced you that there is more going on in most photographs than we usually see, then I have accomplished what I set out to do. And if I have sharpened your perceptions as you look at photographs, all the better.

I never expected you to agree with all my interpretations. I did hope my photolanguage observations would inspire you to ponder where we agree and where we disagree. There will always be some photographs or elements within a photograph that lead most people to the same conclusion, just as there are others that are too ambiguous for consensus.

Just for the fun of it, I have selected some photos for you to analyze on your own. I have deliberately withheld the contextual information for these pictures. Instead, I encourage you to use your imagination freely in applying the photolanguage skills you have learned to create your own stories. You may be surprised at how easy it is to come up with stories that are compelling and fascinating. Have fun with it!

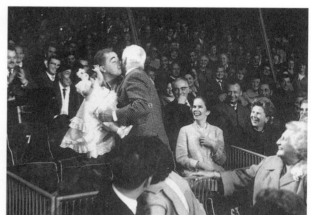

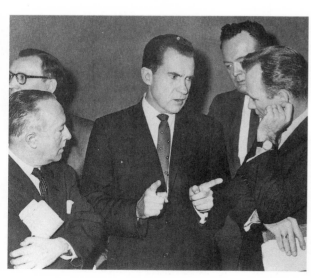

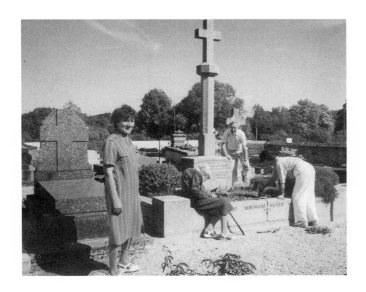

Acknowledgments

First I want to thank my friend and colleague Daniel Klein for being there at the right time with all his enthusiasm and skills. I wish to thank my daughter Kim Cookson for her careful reading of the manuscript, especially her clear-minded opinions about specific passages. My appreciation also goes to John Daniel for his computer and editing skills and to Chris Welch for her creative design for the book and jacket. I also thank Howard Morhaim, my literary agent, and my editor, Susan Barrows Munro, for their abiding faith in this project. Finally, thanks to my loving wife, Ann, who helped select and research the public and private photographs.

Photo Credits

Archive Photos
Pages 23, 47, 48, 51, 53, 57, 59, 62, 64, 67, 69, 71, 73, 74, 77, 79, 83, 84, 87, 91, 92, 95, 97, 98, 100, 103–105, 107, 111, 113, 115, 116, 118, 120, 121, 123, 124, 126, 127, 129–131, 133, 139, 140, 143, 144, 146, 147, 149, 151, 154, 156, 159, 160, 163, 165, 167, 169, 170, 171, 175, 177, 178, 181, 182, 186, 189, 190, 196, 197, 199, 202, 204–208, 210, 228, 232, 234, 235, 237

Personal Collections
Pages 21, 28, 31, 34, 37, 38, 41, 88, 89, 108, 134, 135, 152, 153, 157, 173, 184, 191, 193, 201, 216, 218, 219, 221, 223, 227, 234–238

The Museum of Modern Art
Pages 43, 231

Larry Barns
Page 194

Gigi Kaeser
Pages 225, 238

Padraic Spence
Pages 28, 155, 213